ROYAL GREENWICH

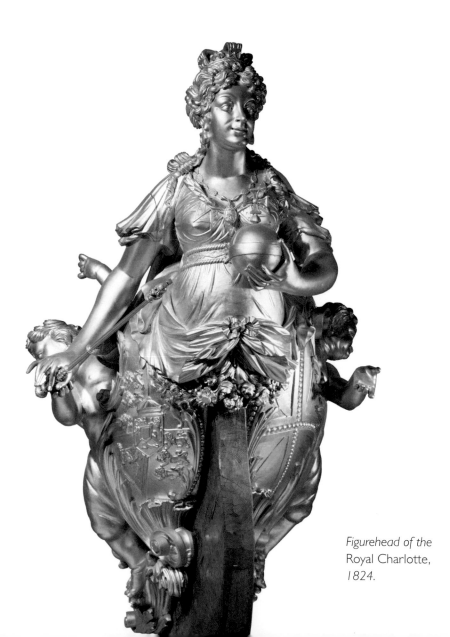

Figurehead of the Royal Charlotte, 1824.

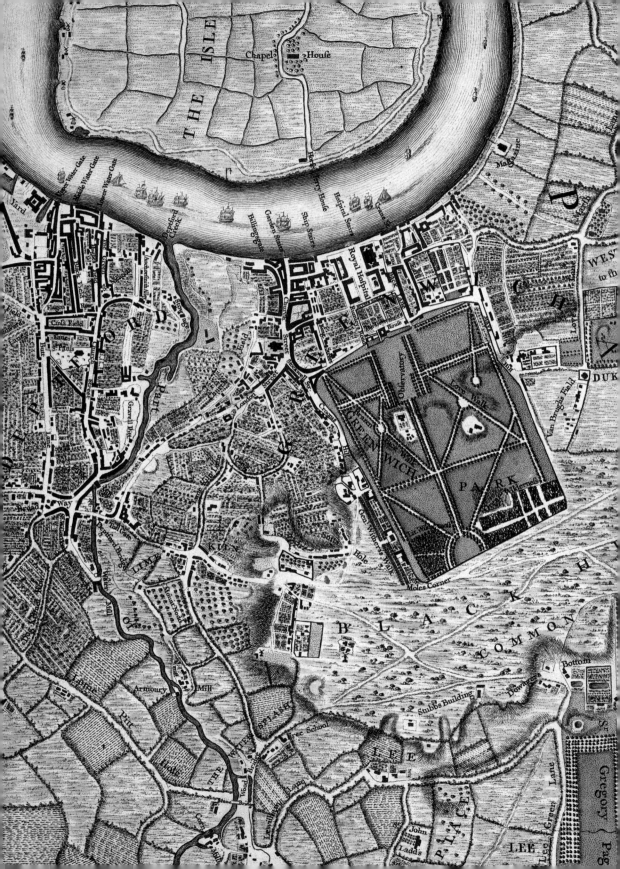

ROYAL GREENWICH

A History in Kings and Queens

PIETER VAN DER MERWE

Author's note

This book sketches the royal history of Greenwich through the reigns of the English (and later British) monarchs involved in it to a greater or less degree – in summary to the end of the Plantagenet dynasty in 1485 and then individually up to date.

The main focus is on the historic 'Park-and-palace' area now comprising the Maritime Greenwich World Heritage Site, as inscribed by UNESCO in 1997, not the entire modern borough of Royal Greenwich, in which that is just a small area on the western side. Related events on Blackheath, immediately south of Greenwich Park, are also only briefly noted for reasons of space.

Such an account is necessarily selective, excludes more national history than it includes and greatly simplifies complex matters: where opinion aims to help explanation, it is often also based on general rather than specialised knowledge. Exact dates for things such as building changes vary between sources, even authoritative ones, and are best considered as approximate in some cases. Illustrations are largely from the National Maritime Museum collections.

Maritime Greenwich
WORLD HERITAGE SITE

Published in 2020 by the National Maritime Museum,
Park Row, Greenwich, London SE10 9NF

9781906367756

Text © National Maritime Museum, London

Written by Pieter van der Merwe

At the heart of the UNESCO World Heritage Site of Maritime Greenwich
are the four world-class attractions of Royal Museums Greenwich –
the National Maritime Museum, the Royal Observatory, the Queen's House and *Cutty Sark*.
www.rmg.co.uk

A CIP catalogue record for this book is available from the British Library.

Designed by Louise Millar

Printed and bound in the UK by Gomer Press

MAP ON PAGE 2: *Detail from a map of Deptford, Greenwich, Woolwich, Blackheath and Eltham by estate surveyor and garden designer John Rocque, in 1746.*
CLOCK ON PAGE 3: *The dial of John Harrison's 'H4' timekeeper, 1759.*

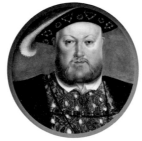
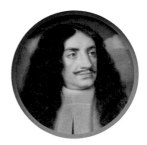

Contents

A Bend on the River 6

House of Tudor 20

House of Stuart 52

House of Hanover 102

House of Saxe-Coburg and Gotha 134

House of Windsor 144

List of Monarchs, 1066–1485 168

Further Reading 170

Acknowledgements 170

Index 171

Image Credits 176

A BEND ON THE RIVER

Time before memory

Today's view from the Royal Observatory at Greenwich is of uninterrupted city round the full sweep of the northern horizon. Except for the Royal Park immediately below, only the far rim of the Thames escarpment from Highgate to the hills of Essex seems wooded and green but that is largely an illusion of distance. It is impossible to imagine the Greenwich landscape of prehistoric, Roman and Saxon times; one of river and marsh, with forest as far as the eye could see and yet more into southern haze beyond the sandy scrubland of Blackheath.

Scattered feathers of rising smoke would have been the first signs of human occupation, initially by hunter-gatherers.

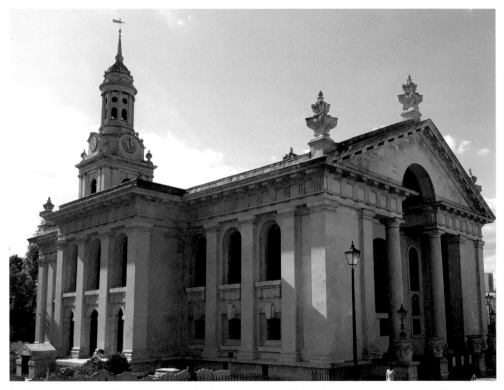

St Alfege, Greenwich. Hawksmoor finished the church in 1714 after the medieval one collapsed in 1710. It was consecrated in 1718.

Clearings later expanded into fields, as early farming and fishing villages along the Thames drove the trees back and gained the names they still hold as parts of modern London. Greenwich is one such, general consensus being that it derives from the 'green inlet' or 'bay' (river-bend) where Viking raiders were based for several years and, in 1012, murdered Alfege, the captured Archbishop of Canterbury, on the site of the parish church that commemorates him.

Nearly a thousand years earlier the invading Romans had established a military or administrative base on the high east side of the Park, its former presence between the first and fourth centuries marked there by significant remains of a Romano-British shrine; the site has yielded several fragmentary inscriptions and well over a hundred coins from that period. The main evidence of later Saxon occupation lies high on the west side, where an area of low mounds near Macartney House (the childhood home of General James Wolfe 'of Quebec') are remnants of a large seventh-century barrow cemetery.

The unnamed Roman outpost flanked their road from Dover to London (Watling Street), which came west in a straight line over Shooters

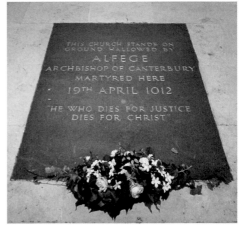

Memorial to Ælfheah (Alfege), Archbishop of Canterbury, killed at Greenwich during a drunken Viking feast on 19 April 1012.

Hill to Blackheath Standard (as it still does) and then crossed the Park diagonally. Whether its main course did so in the same straight line, north of the Observatory, or bent south behind it is less clear and partly depends on where it crossed Deptford Creek, but there would certainly have been a spur down to a landing place at Greenwich.

Whatever other reason the Romans had for putting a base on the hill – perhaps as part of a Blackheath training area – one was its ideal position to watch both the land approach to London from southward, and to north and east down the Thames. It is no surprise that in the early fifteenth century, Henry V's brother Humphrey,

Duke of Gloucester, built or at least improved a pre-existing watchtower with even better all-round views on Greenwich hill itself. Today the Observatory covers whatever remains of its foundations.

King Edgar (c.943–75), *from the New Minster Charter of 966 (British Library).*

Saxons to 'Good Duke Humphrey'

Local royal associations only firmly date from 964, when the Saxon king, Edgar 'the Peaceful' (c.943–75), granted the manor of Lewisham and East Greenwich to the Benedictine Abbey of St Peter at Ghent, in what is now Belgium. It had belonged to Alfred the Great since 871 but while the documentation of its gift to the Benedictines in 918 by his daughter Elstrudis, Countess of Flanders, is questionable, the Abbey's possession was reaffirmed over successive reigns.

Until well into the seventeenth century, however, 'East Greenwich' meant the present town, 'palace', Royal Park and surrounding area: even today, they are in 'the Royal Manor of East

Greenwich'. 'West Greenwich' was the north or Thames end of Deptford, on the other side of the Creek: that, for example, was birthplace in 1155 of the Norman 2nd Baron Geoffrey de Saye, one of the signatories of Magna Carta in 1215. Both he and his father (also Geoffrey, 1st Baron) were 'Lords of West Greenwich' and the family name continued in Sayes Court, the later Deptford manor house, gardens and estate that in the seventeenth century were owned by the diarist John Evelyn (1620–1706). Recent archaeology has excavated the house foundations but only a fragment of the grounds survives as modern Sayes Court Park.

In 1396 a report to the Abbey stated that 'La maison de Grenewyc' was the first in the town as one came upstream. It was by then a group of buildings later called Old Court (a name also applied to the whole manor), on the present site of Greenwich Power Station. The main one was a hall, already reported 'old' in 1268, that was large enough to host a manorial court and receive important visitors. Towards the fields there was also a long-lasting gatehouse, with rooms above, and both were tiled buildings, others being thatched. The Abbey's local lands were also productive agriculturally, and of timber,

with Greenwich a significant out-port for them; river fishing well downstream was undoubtedly also part of the Greenwich livelihood.

The 1086 Domesday survey of William I (the Conqueror) recorded eleven mills in the Abbey's Lewisham and Greenwich estate. Those on the river are likely to have been tidal-powered, and in 2008 the substantial timber foundation of one dating to around 1200 was found under a wharf area off Banning Street, in modern East Greenwich: it measured 10 x 12 metres, with a five-metre wheel. Such things could only have been built

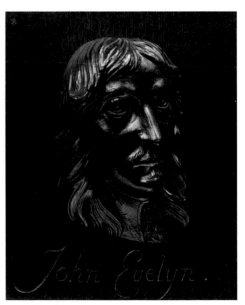

John Evelyn (1620–1706), diarist, horticulturalist and first Treasurer of Greenwich Hospital; a contemporary relief portrait in carved oak.

by a noble or ecclesiastical landholder and in 'medieval East Greenwich' – today's Park and town area – it was the Prior of Lewisham for over 400 years.

Abbey rights, however, were partial not total: that is, to work land and collect rents and other manorial dues, not freehold possession. The Crown still had interests and a duty to those of its subjects. In 1300 Edward I made offerings to the small chapel of the

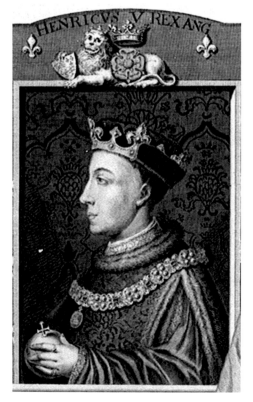

Henry V (b. 1386, r. 1413–22); engraved by George Vertue (1684–1756).

Virgin at Greenwich, location uncertain. Edward III (1312–77) also often resided at Greenwich, probably in a large hall-house of which remains lie under the east side of the lower Grand Square of the Old Royal Naval College. Direct Benedictine management of the area also steadily weakened: the Prior of Lewisham permanently withdrew to Ghent by 1376 and the Abbey became even more of an absentee landlord, sub-letting increasing areas to private interests.

By the time Henry IV (1367–1413) signed his will from his 'manor of Greenwich' in January 1408, several kings had been obliged to deal with resulting difficulties and the cross-Channel division of loyalties caused by the Hundred Years War. In 1414, the year before the Battle of Agincourt, Henry V finally stripped all foreign religious houses of property rights in England: from then on Greenwich, as the historic town is now understood, was solely in royal hands.

Henry V first granted the manor to Thomas Beaufort, Duke of Exeter, who died at Greenwich on 31 December 1426. This was four years after the king himself, when his son, Henry VI, was only nine months old. Unsurprisingly perhaps – but fuelling long enmity with the Beauforts – Greenwich next passed to the boy-king's

uncle Humphrey, Duke of Gloucester (1390–1447), Henry V's youngest brother. Under a regency council, he became Lord Protector of England during his nephew's minority. Henry VI was crowned in 1429 but as a timid, religious youth with a history of mental instability, he was only declared fit to rule in 1437.

Humphrey was a proven soldier who had fought at Agincourt and also a well educated patron of humanist learning. 'The most lettered prince in the world', according to a contemporary, he presented 263 of his books (all in manuscript) to Oxford University; it previously had only about 20 and 'Duke Humfrey's Library' prefigured the Bodleian, though only three of his volumes now survive there. But while the aggressive patriotism and intellect of 'Good Duke Humphrey' made him well-known and popular, he was also opinionated and controversial. He attracted enemies, led by the Beauforts and finally including the new queen, Margaret of Anjou, whom Henry VI married in 1445.

Things went well in the early part of the reign, however. From 1428, when Humphrey married his intelligent mistress Eleanor Cobham as his second wife, he began a new riverside manor immediately west of the earlier royal building occupied by Thomas Beaufort, which he presumably also initially used. Called 'Bellacourt', the new one was crenellated, walled about and finished around 1433. In that year Humphrey also gained permission from Henry VI to enclose what is now Greenwich Park, originally with a fence, and also 'newly crenellate' what became known as Duke Humphrey's Tower where the Observatory now stands.

That suggests this watchtower was already there and being embellished to

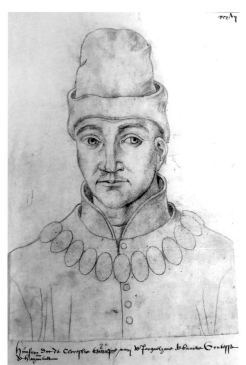

Humphrey, Duke of Gloucester (1390–1447); 15th-century drawing attributed to Jacques le Boucq.

double as a Park hunting lodge, although record of deer being introduced only dates from 1510. The Park boundary remained a fence until 1619, when James I began replacing it with the present brick wall. That was finished in 1625 at a cost of just under £2,002: the equivalent now would be about £495,000.

Humphrey and Eleanor were briefly the centre of a small but glittering artistic, literary and intellectual court at Greenwich, but the death in 1435 of his elder brother John, Duke of Bedford, saw a turn in their fortunes. While it made Humphrey heir presumptive to

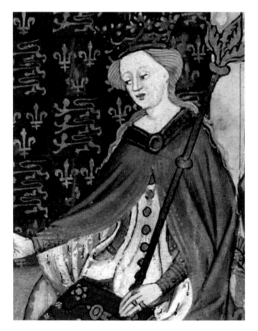

Margaret of Anjou (1430–82), Queen Consort of Henry VI; from the Talbot Shrewsbury Book, 1444/5 (British Library).

the throne, his claim to become Regent during Henry VI's extended minority was strongly opposed.

In 1441, Eleanor consulted astrologers who predicted Henry's early death, and rapidly found herself convicted of witchcraft. After being made to do public penance and divorce her husband, she was imprisoned for life. Her 'co-conspirators' were executed and Humphrey was largely forced out of public affairs. His final defeat was achieved after the 15-year-old Margaret of Anjou became queen; for even before her marriage, the Beauforts persuaded her that Henry's uncle was a threat to the weak husband for whom she was soon a powerful deputy.

In February 1447 Humphrey was summoned to a parliament at Bury St Edmunds and arrested for treason on arrival. Within hours he appears to have suffered a stroke and died three days later. This naturally prompted suspicions of murder, not least since his heirs were being dispossessed of his lands and offices even before his death. By Easter, Margaret had secured Greenwich for herself while her pious husband diverted his uncle's remaining books to his own foundation – King's College, Cambridge.

Placentia and the later Plantagenets

Queen Margaret's first act at Greenwich was to change the manor's name: in accounts from 1447 it became 'Pleasaunce, the Queen's parke, late Bellacourte', or 'Placentia': both forms meant 'pleasure place'. She rapidly also began a five-year programme of rebuilding and expansion, starting by reglazing all the windows *cum margaritis* (with daisies, the symbol of her own name) in stained glass. The work was done under Robert Ketelwel (or Kettlewell) who also supervised works at nearby Eltham Palace and was eventually buried with his wife in St Alfege, Greenwich. Surviving accounts show a burgeoning of new courtyards, pavilions and lavish expenditure on fittings and furnishing. The old manor became a new palace of pink brick, white stone and sparkling bay windows, but no image has survived of either the old or new complex.

Nor did Queen Margaret's ascendancy bring an era of peace. Humphrey's fall had been one effect of the deteriorating English war situation in France, magnifying baronial rivalries at home. The belief that such a respected figure as Humphrey had been murdered was also one of the reasons why, in June 1450, many of all ranks in Greenwich joined Jack Cade's rebellion on Blackheath, which was a general popular protest against corruption and other abuses of royal power.

By the time it came to a negotiated end (after Cade was killed elsewhere) those considered responsible for engineering Humphrey's death had themselves been dispatched. As a condition of royal pardon, however, the men of Kent (including Greenwich) had to do humiliating penance before Henry VI on Blackheath in 1451. In February 1452 it was also where Richard, 3rd Duke of York and previously Humphrey's ward, again appeared with an armed force prepared to confront the king, as conflicting currents of baronial allegiance shifted in response to his unsteady grip on both sanity and control.

The growing tensions were between the two Plantagenet cadet houses of Lancaster – that of the king – and of York, both with legitimate lines of inheritance to the throne. From 1455 these conflicting interests broke out into the chaotic thirty-year Wars of the Roses (red for Lancaster and white for York).

Plantagenet

'Plantagenet' was the nickname, probably referring to the yellow-flowering broom (*planta genista*), of Geoffrey V of Anjou, Duke of Normandy (d. 1151), who married Matilda, daughter of Henry I and great-granddaughter of William I (the Conqueror). It was adopted as a surname by their descendant Richard, 3rd Duke of York – father of Edward IV and Richard III – but the Tudors began the modern practice of applying it back to Geoffrey and Matilda's son Henry II (1154–89). He was the first Angevin king of England as, strictly speaking, all 14 Plantagenets were: the last six, from Henry IV to Richard III, belonged to the cadet (junior) houses of Lancaster and York. The familiar 'three lions of England' became a Plantagenet emblem from 1198.

Their first phase saw Henry VI deposed in 1461 and Edward, 4th Duke of York, crowned king, after which he gave Placentia to his wife, Elizabeth Woodville (m. 1464). Although raised at nearby Lee, she was not locally popular and the marriage, originally secret, was also controversial. This was partly owing to her low status (her father was only an earl) and because it was opposed for state reasons by Edward's main backers, notably Richard, Earl of Warwick (called 'the Kingmaker'). After Warwick switched sides, Henry VI was briefly restored to the throne in 1470 and Edward driven abroad.

Early in 1471 he counter-attacked, landing on the Yorkshire coast, with Burgundian support from Flanders. Following victories at the Battles of Barnet and Tewkesbury he re-entered London on 21 May, where King Henry mysteriously died in the Tower almost within hours, presumed murdered. His young son (also Edward, b. 1453) had already been killed at Tewkesbury and

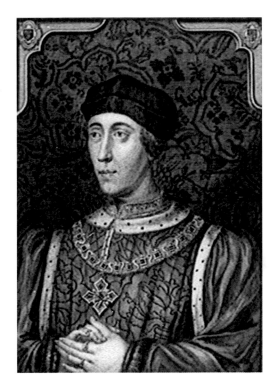

Henry VI (b. 1421, r. 1422–61 and 1470–71); engraved by George Vertue from a set of five Plantagenet kings painted for Henry VII or VIII, c. 1504–20. They are the earliest paintings still in the Royal Collection.

Queen Margaret was imprisoned until ransomed into French exile in 1475, where she died in 1482.

While Queen Elizabeth (Woodville) resumed her briefly interrupted possession of Placentia, Edward IV's main local contributions lay elsewhere. First, in the 1470s, he built the still-standing Great Hall at nearby Eltham Palace, where Henry VIII would spend his childhood. More significantly for Greenwich, in 1481 he obtained a licence from Pope Sixtus IV to establish a convent of Franciscan Observant friars there, and the following year granted them a site immediately west of Placentia.

This included some old buildings and a walled patch of open ground 'where the game of ball used to be played'. The first 'grey friar' brothers arrived from Flanders before the site was dedicated by the Bishop of Norwich on 2 July 1482, but lacking funds to construct anything, they first lived in the town and used a small, earlier local chapel of the Holy Rood, somewhere just south of today's *Cutty Sark* dry-dock.

'A View of the Ancient Royal Palace called Placentia, in East Greenwich', by James Basire.
It shows the Tudor Palace of Greenwich in the reign of Henry VIII.

On Edward IV's death in April 1483 his son, the 12-year-old Edward V, did not live to be crowned: he and his younger brother Richard, 'the Princes in the Tower', were first placed there for safety but never emerged. For although their father's will had appointed their uncle Richard, Duke of Gloucester, as Lord Protector, he seized advantage of a claim that their mother's marriage was invalid, rendering them illegitimate. This won Parliamentary support and, as last of the Yorkist and Plantagenet kings, he took the throne as Richard III. The two princes almost certainly died in the Tower but by whose hand remains unclear.

Blackheath in the 1790s; the south wall of Greenwich Park is on the left.

Blackheath

Blackheath – probably first meaning 'bleak heath' – was once a more extensive, sandy and irregular area than today. The enclosure of Greenwich Park in 1433 pushed its northern boundary well back from its natural one on the rim of the Thames valley, where the Royal Observatory now stands, and the plateau within the upper Park then became greener by long and deliberate planting.

Between the Park and Blackheath village the heath was legally 'manorial waste'. It was eventually much quarried for sand and gravel into the nineteenth century and this created huge pits between roads across it. The sole survivor today lies off Maze Hill, near the Park's south-east corner, filled with the gorsey scrub that also once made the heath a haunt of highwaymen and footpads. After the Second World War, the other disused pits not already filled in were levelled up with London bombing rubble and turfed over.

As open ground, Blackheath was a natural point for mass-assemblies and early examples were either dangerously subversive or ceremonial. The former include the Peasant's Revolt led by Wat Tyler in 1381 (under Richard II); Jack Cade's Kentish rebellion in 1450 (see p. 15) and Henry VII's defeat of Cornish rebels in 1497, on the western slopes above Deptford Bridge: hundreds died and on its 500th anniversary in 1997 a Cornish-slate plaque was set in the wall just east of the Blackheath Gate to the Park commemorating their executed leaders, Michael Joseph the Smith (Michael An Gof) and Thomas Flamank.

In 1400 Henry IV met the Byzantine Emperor Manuel II Palaiologos on Blackheath when he visited Europe seeking aid against the Ottoman Turks and in 1415 the Lord Mayor and leading citizens of London formally welcomed Henry V there on his victorious return from Agincourt. The following year the Holy Roman Emperor Sigismund also arrived there to mediate Anglo-French peace. City dignitaries turned out again for Henry VI's and Edward IV's later homecomings from France in 1431 and 1474. From the late seventeenth and into the eighteenth centuries the heath also became a place for army assembly and reviews.

HOUSE OF TUDOR

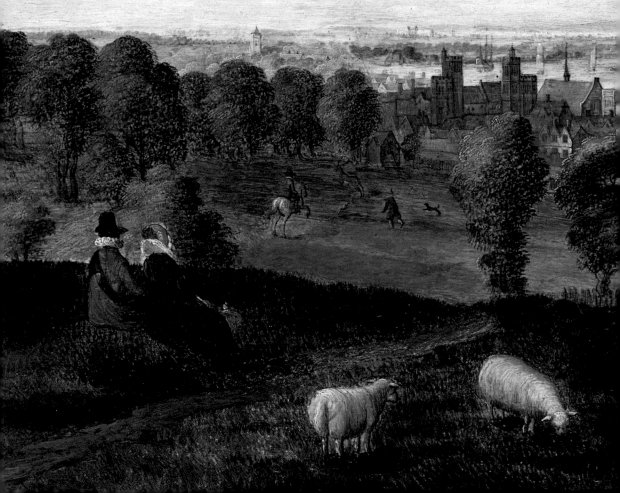

Greenwich from the south-east, showing the
Park and part of the Tudor palace, about 1620.
Greenwich Castle is on the hill, far left.

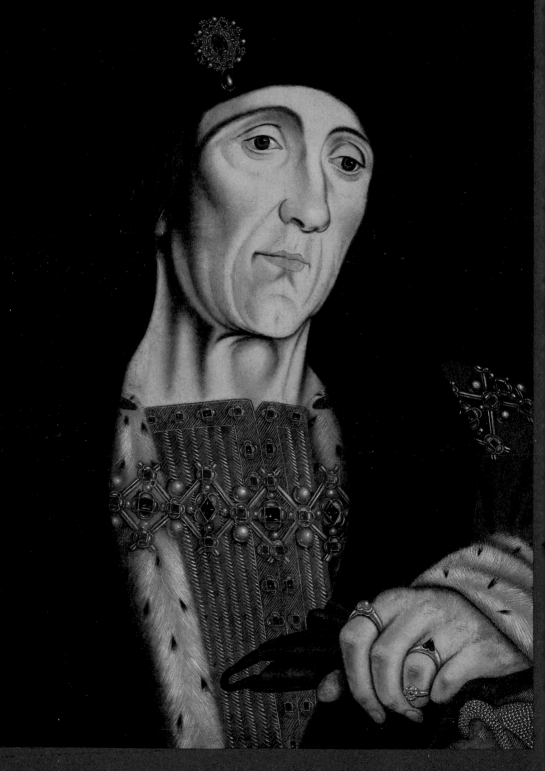

HENRICVS VII

Henry VII
(b. 1457, r. 1485–1509)

Richard III's reign was short. He immediately faced rebellion by Lancastrians who thought him a usurper and this time the key figure was Henry Tudor. Henry was partly Welsh and through his forceful mother, Lady Margaret Beaufort, a great-grandson of Edward III. After a failed revolt launched from Brittany in 1483, he escaped to France but, with French aid, landed again in South Wales on 7 August 1485: he then moved fast to compensate for still-limited strength.

Two weeks later Richard became the last English king to die in battle and Henry the last to gain the throne that way, near Bosworth, Leicestershire, on 22 August. Richard was quickly buried near the altar of the long-vanished Greyfriars' Church at Leicester: in 2012 his bones were identified, still undisturbed beneath an asphalt car park, and in 2015 more royally entombed in Leicester Cathedral.

Henry VII, 1457–1509. A 16th-century copy from Holbein's dynastic group portrait of 1537, centring on Henry VIII and lost in the Whitehall Palace fire of 1698.

Even before his first rebellion, Henry had secured support by publicly vowing to marry the murdered Edward V's sister and legitimate heir, Elizabeth of York. He did so at Westminster Abbey in January 1486, after previously being crowned in his own right. The marriage, successful in itself, effectively ended the Wars of the Roses by reuniting the Plantagenet royal lineage of both Lancaster and York in the new Tudor dynasty.

Although ruthless when necessary, Henry was a peaceable rather than warrior king, with the political cunning to maintain control over fractious vassals. Where money was concerned he was both parsimonious and rapacious, making himself vastly rich but also boosting trade and restoring national finances.

The consequence at Greenwich between about 1498 and 1504, towards the end of his reign, was the replacement of Margaret of Anjou's 'Pleasaunce' with a new Tudor palace of equal magnificence, and this time visually recorded. Its eventual glories under Henry VIII were extolled (in Latin) by the poet John Leland:

Lo, with what lustre shines this wished
for place!
Which star-like, might the heavenly
mansions grace.
What painted roofs! What windows
charm the eye!
What turrets, rivals of the starry sky!…

Built under the direction of Robert Vertue and reusing some of the Placentia foundations it centred on a donjon-like five-storey tower of king's apartments on the river, with its main 'Conduit' (water-supply) courtyard of two-storey ranges behind, and a lesser court to the east. Queen's apartments were on its west and later south side, and then gardens as far as the Deptford-to-Woolwich road (on the line of the present National Maritime Museum [NMM] colonnades) with the Park beyond. The great hall lay on the east of the main courtyard behind an extended river frontage that ran parallel to a more south-easterly shoreline than today, and at a lower ground level, with the royal chapel as a projecting spur at the east end.

The whole sprawling complex is best seen in aerial drawings made by Anthony van den Wyngaerde *c*.1559, after further additions by Henry VIII. On the west side they show the Greenwich Observant friary, with its off-centre-spired church, set back a short way from the riverfront. Probably because the Franciscans were at last ready to start new building work, Henry VII in December 1485 reconfirmed their earlier grant of

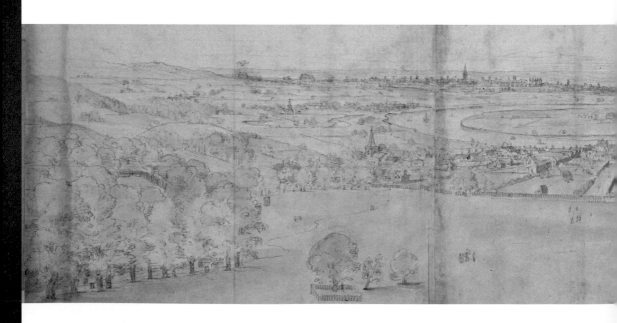

land there and the church was formally dedicated on 8 April 1494. The domestic quarters for a warden and at least a dozen Franciscan brothers – though there were later over thirty – lay to the south with a garden and small friars' cemetery.

Placentia and the Palace of Greenwich were principal seats of Tudor rule until the 1530s and in 1491 it was at Placentia that the future Henry VIII was born, the third of his parents' four children who survived infancy. When nearly 80, Bishop Richard Foxe (the sole source) said he baptised Henry in the Friars' Church. Since it was not then consecrated or probably complete, the royal chapel in Placentia may be more likely: a tradition it occurred in St Alfege, the parish church, lacks evidence.

Henry's elder brother Arthur, Prince of Wales, who died in 1502, was born at Winchester in 1486; Princess Margaret – grandmother of Mary, Queen of Scots and key link to the Stuart succession of 1603 – followed at Westminster in 1489. Princess Mary – later briefly Queen of France and, by her second marriage, grandmother of Lady Jane Grey – was born at Sheen Palace in 1496. Their mother Elizabeth died after the birth of her last daughter, Katherine, in 1503. When tuberculosis in turn claimed Henry VII on 21 April 1509, his 18-year-old second son inherited not only a royal fortune but, for a change, a relatively prosperous and stable kingdom.

'Greenwich Palace from the Park' by Anthony (Anton) van den Wyngaerde, c.1559. Wyngaerde was a Flemish artist who came to England with Philip of Spain.

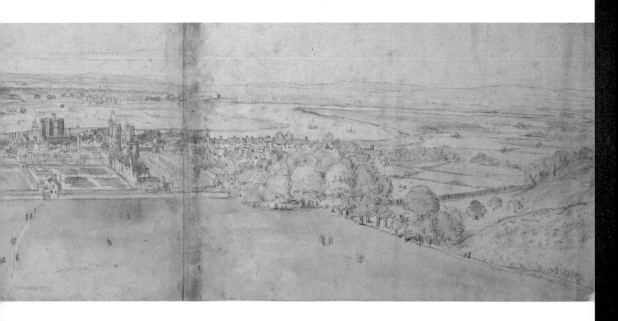

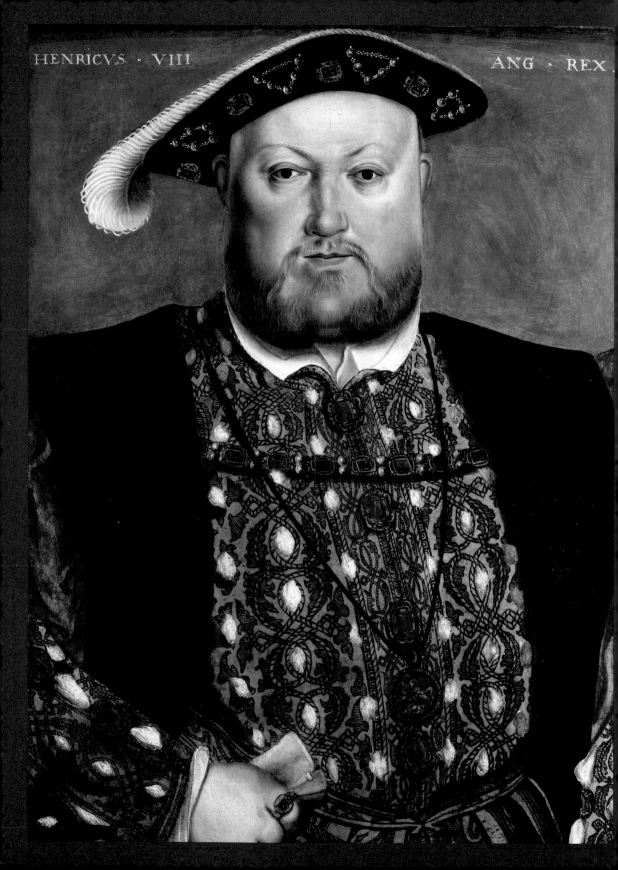

HENRICVS · VIII ANG · REX ·

Henry VIII
(b. 1491, r. 1509–47)

The kyng beyng lusty, young and couragious, greatly delighted in feates of chyvalrie, in so much that he made a chaleng of Justes, againste all commers to be proclained at his mannoure of Grenewyche…

(Hall's Chronicle, 1511)

Prince Henry was highly intelligent and absorbed a Renaissance humanist education from the best teachers available. He grew up with the other younger royal children largely at Eltham Palace where, aged nine in 1499, he impressed the great Dutch scholar Erasmus during a brief visit with Sir Thomas More.

Even after his older brother Arthur's death, he had little training in statecraft but was fluent in Latin and French, had knowledge of other languages, became learned in theology, was very musical, and interested in science and technology,

Henry VIII, 1491–1547. Probably by one of Holbein's studio assistants, this is closest to another Holbein-pattern version now in Rome.

especially as applied to warfare. With that in view as the business of a king, he also excelled in martial sports to a hazardous level. A lifelong rider and exceptional jouster, he narrowly escaped a lance in the eye at Greenwich in 1524 and only finally gave up in 1536 after being knocked off and under his fallen horse there, in full armour: he was unconscious for two hours.

Henry was England's most powerful monarch in terms of personal rule and one of the most risky to serve in any high position. His will, however inconsistent, eroded contemporary means of control and he required not just able obedience but also express conformity to the English Church, of which he made himself head for wholly self-serving reasons. One was to outflank what he saw as God's punishment in denying him a male heir for breaking canon law by marrying his older brother's widow (Catherine of Aragon), even though that marriage was annulled as unconsummated.

His daughter, Queen Elizabeth I, reputedly said that opening 'windows into men's souls' was not her business

but her father thought it his undeniable right, with long-lasting constitutional consequences. Although charming, charismatic and rare for an English monarch in his intellectual and artistic talents, Henry was ruthlessly egocentric in a way akin to more recent political strongmen who have made ideological as well as practical compliance the test of loyalty, and loss of trust often as fatal as opposition. This is simplistic but worth setting against the more popular snapshot of him as a jolly, fat and splendidly dressed king, famous for having six wives.

As far as Greenwich is concerned, the Henry to envisage is the tall, handsome figure of his early reign rather than the domineering, overweight one of later years – although a steely gaze is common to all adult portraits. His Greenwich activities are better recorded than for any other king, partly through building accounts and diplomatic reports, but also because a Londoner called Edward Hall (d. 1547) kept a detailed and published *Chronicle* of the reign. These sources provide a good outline of the general round of court activity.

Whitehall Palace was badly damaged by fire in 1512 and, once king, Henry's early attachments to Eltham – a small palace although with a much larger

The Castle of Loyalty, set up in the Greenwich tiltyard for jousts at Christmas 1524–25. It was 20 feet square, 50 feet high and had a 15-foot dry moat around it.

hunting park that he continued to use – soon transferred to Greenwich. It was better suited to his martial interests and international diplomatic purposes, given that jousts and related entertainments were integral to these, and it became one of the few palaces that could accommodate the full court of about 600. Easy access by river from London, the sea and the Dover road across Blackheath were also in its favour.

Henry was prime founder of the Royal Navy and by 1514 had created royal dockyards to build and maintain his ships at both Deptford and Woolwich, with Greenwich in between and less than a mile from Deptford. His apartments in the palace tower, with its fine river view, gave him direct access to the Thames and had amenities including a library: of his 1,450 books at death, 329 were at Greenwich.

In 1510 he first stocked the Park with deer. He also held early jousts there until 1514 when, after building new stables, he began the first permanent 'tiltyard' attached to an English palace on the east side of its Great Garden, both of which stretched back to the old Woolwich road (running under the present Queen's House). Measuring about 600 x 250 feet (180 x 76 m), the tiltyard's eastern side ran along Back Lane (modern Park Row) and the north end lay under the Queen Mary Court of the Old Royal Naval College. When complete in 1518 it included, on its west side, twin brick towers for mock assaults linked by a viewing gallery; part of their foundations still lies under the NMM north-east lawn.

Regular and spectacularly caparisoned jousts were held there, with Henry usually competing until around 1530. Jousts formed part of the Greenwich welcome for the Holy Roman Emperor Charles V in 1522, when he made a long state visit partly to discuss possible marriage to Henry's then six-year-old daughter, Mary.

The tiltyard saw further development in 1527 when, to receive a major French embassy, Henry added a 100-foot banqueting House west of the tiltyard towers. It connected to the north end of a pre-existing armoury gallery, with a new disguising house (theatre) added at the same time south of that. This long new interconnecting range also linked back to the Palace by a covered way (with a bowling alley below).

By this time both the astronomer Nicholas Krautzer and the painter Hans Holbein were in Henry's employ and, after jousts and a feast, there was a formal diplomatic gift-exchange in

the disguising house, beneath a painted recreation of the heavens that was Holbein's first work for Henry. The seating plan for a previous and equally elaborate French embassy banquet of 1517 survives, though that was in the Presence Chamber.

At other times such as Christmas and New Year – when the home-focused court gift-giving also often took place at Greenwich – the Great Hall was also used for masques, dancing, music and indoor feats of symbolic chivalry: as Henry aged, these less rugged activities predominated. To mark New Year's Eve 1511–12, for example, Hall's *Chronicle* notes that it was fitted up with 'a castle, gates, towers, and dungion, garnished wyth artilerie, and weapon after the most warlike fashion: and on the front of the castle, was written le Fortresse dangerus, and within the castle were.vi. [six] ladies, clothed in Russet Satin…' to be liberated by gallant assault.

Adjoining the tiltyard towers the armoury gallery displayed the armour first made at Greenwich under Henry. Whether for battle, parade or the jousts, these often elaborately decorated masterpieces of craft technology were high currency of courtly status and diplomatic exchange, but they were not manufactured in England until he imported Italian and Flemish armourers in 1511, and later mainly 'Almain' (German) ones, originally based in Southwark.

Although they were working at Greenwich by 1515, it was only from 1517 that Henry added a purpose-built armoury, beside the friary, where it continued to produce distinctive top-grade work until closed in 1649. Output included armour for the king's use and as royal gifts, and for favoured courtiers permitted to order it: examples of Henry's own and others survive, with many recorded in contemporary images. Other improvements by Henry included remodelling the Palace Chapel about 1519, a full-height watergate extension to the King's Tower over the intervening river walk, and in 1532–4 the addition of kennels, a cockpit, an unusual upper-floor hawking mews (a later-life pastime), and a real tennis court.

Henry married both the wives he later divorced at Greenwich; the first, Catherine of Aragon, in 1509 (in the Friars' Church) and the fourth, Anne of Cleves, in 1540, after a magnificent royal welcome on Blackheath. The pious Catherine was a regular communicant at the Friars' Church, including for small-hours services, and Henry also strongly approved of the brothers in his early reign.

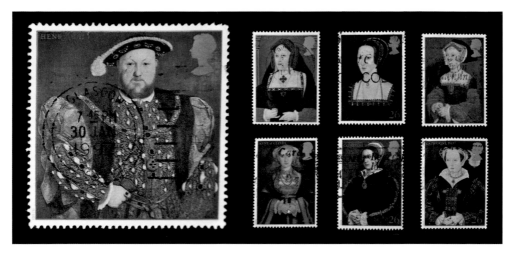

Henry VIII and his six wives, in commemorative stamps: (top) Catherine of Aragon, Anne Boleyn, Jane Seymour; (bottom) Anne of Cleves, Catherine Howard, Catherine Parr.

This changed from Easter 1532, when his 'great matter' of divorcing Catherine, for failure (after many miscarriages) to produce a surviving son, earned him direct criticism from its pulpit by the Franciscan 'provincial', William Peto. The Greenwich friars then sealed their fate by refusing to accept him as self-appointed head of the Church in England – his response to Papal refusal of a divorce – and from 1534 the friary, and others, became the first religious houses closed in his abolition of the English monasteries. From the 563 'dissolved' he eventually made £1.3 million (about £360m now) by seizure of their lands and other assets. Most of the Greenwich friars were imprisoned, where many died or were killed – one strangled with the cord of his own habit. Survivors were exiled and their church repurposed from 1543 as a plate mill for the armoury.

Queen Catherine's daughter, Mary, was born at Greenwich in 1516 and so was Queen Anne Boleyn's, Princess Elizabeth, in 1533: both were baptised in the Friars' Church, with details well recorded in Elizabeth's case. But when Anne also failed, after three miscarriages, to produce the son Henry had confidently expected Elizabeth to be, her star also fell as his eye lit on Jane Seymour (his third wife).

Greenwich was Anne's favoured residence as well as Catherine's. In late 1532 Henry installed her as Marchioness

of Pembroke (and his mistress) at Old Court, which he refurbished for her. They married secretly in January 1533, when she was already pregnant with Princess Elizabeth, although his marriage to Catherine was only declared invalid in May. As queen, it was also at Greenwich on 2 May 1536 that Anne was arrested and sent in her own barge to the Tower. Swift trial for treason followed – on charges of adultery, incest and plotting Henry's death: she was beheaded on the 19th and four other members of the court were also executed, one just a musician, as her supposed lovers and accomplices. Henry and Jane were married on the 30th.

Henry's seizure of newly built Hampton Court from the disgraced Cardinal Wolsey in 1529, and the rebuilding of Whitehall Palace in the 1530s, diminished use of Greenwich in his later reign. So did his age, obesity and declining health – which has been linked to the effects of his earlier jousting injuries. After 1533 he only spent Christmas there again in 1537 and 1543 but last visited three weeks before his death at Whitehall on 28 January 1547, aged 55. Greenwich never lost his stamp, however; for other than the addition of the Queen's House from 1616, the Palace saw little external change until it fell into mid-seventeenth century decay. It also remained a favourite seat of his three Tudor heirs, especially for summer use.

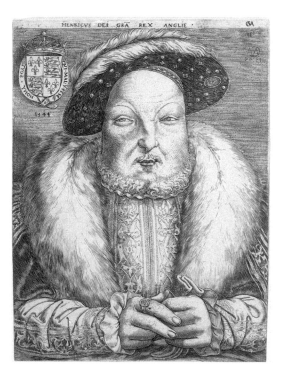

Henry VIII in old age by Cornelis Massys, who published this print in 1548. With no need to flatter, it shows him as a richly dressed but bloated and menacingly suspicious old man.

The Greenwich 'Grey Friars'

The Greenwich friars were Franciscan 'minorites', also called 'Observants' from observing stricter rules of poverty than the larger 'Conventual' branch of the order. They appeared in Scotland and Ireland in the 1440s but first arrived in England – at Greenwich – in 1482 by invitation of Edward IV, not on their own initiative. He probably asked them to come at the urging of his sister Margaret, Duchess of Burgundy (d.1503), who supported the order: she visited his court in 1480 and later presented a richly illuminated gradual (a manuscript chant or hymn book for the Catholic Mass) to the Greenwich brothers.

Greenwich was also literally associated with their name of 'grey friars', from a general English change in their dress to a cheaper cloth in 1502, in line with the poverty rule:

'Aboute Easter this yere, the gray ffreres changed their habyte: ffor where of long tyme before they vsed to were broun russet of iiiis. vid. or viiis. [4s 6d or 8 shillings] a yerd now they were compelled to were kenet [grey, undyed wool] russet of iis. [2s] a yerd; which was brought about by labour of the ffreres of Grenewich and by favour of the bishop of Wynchestre, Doctour [Richard] ffox.'

About 61 English Grey-Friar houses eventually existed and remained an order dependent on royal rather than popular favour. In August 1534 Greenwich led them as the first to go in Henry VIII's dissolution of the monasteries, although a few 'collaborationist' brothers prepared to acknowledge his supremacy in the English Church (and informing on those who did not) appear to have remained there to about 1537.

The Friar's Church; detail from pp. 50-51.

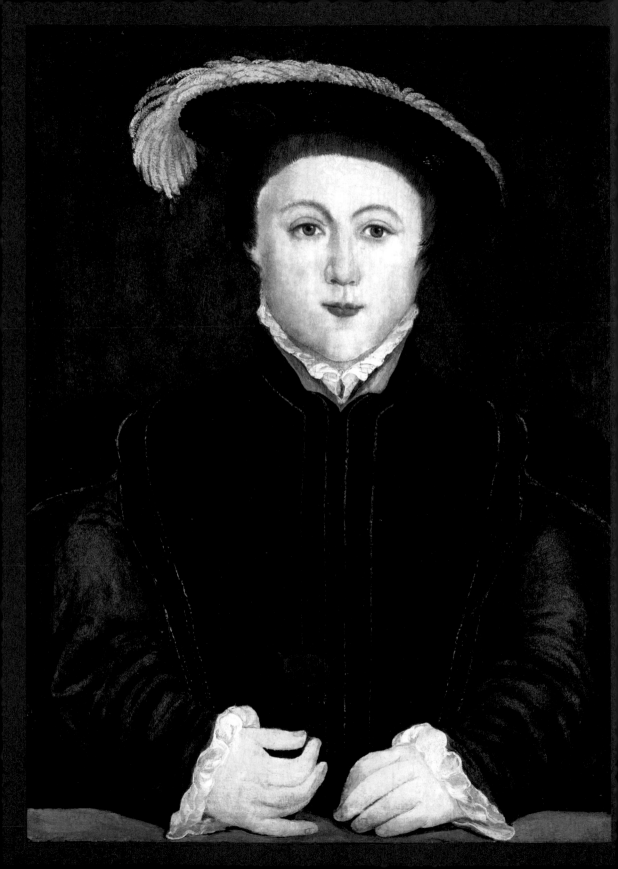

Edward VI
(b. 1537, r. 1547–53)

Edward, Henry VIII's only son, was born to his third wife Queen Jane (Seymour) at Hampton Court Palace in October 1537. His mother's labour lasted three days: she died shortly afterwards and was the only one of Henry's wives to receive a queen's burial, at Windsor, where he joined her in 1547.

Edward flourished: he saw his first Christmas at Greenwich and spent proportionally more time there than either his father or two elder half-sisters, with whom he had good childhood relations. Both were present at his baptism, Mary as godmother. Like his father, Edward was very intelligent and even better educated – as a Protestant – among other selected children. He also had warm support from his father's last wife, Queen Catherine (Parr), as did his sisters.

In 1543, the year of their marriage, Prince's Lodgings were established for him on the west side of Greenwich

Edward VI, 1537–53. A contemporary portrait based on an original by Holbein.

Palace. By the Treaty of Greenwich that July he was also betrothed to the then infant Mary, Queen of Scots, as part of his father's attempt to unify the two kingdoms: the Scots repudiated the treaty in December, however, leading to resumed cross-border conflict.

On succeeding to the throne in 1547, Edward reigned under a regency council in which his Seymour relations played a great part, since he never attained his majority. Although he began to show a wilful temper, his talent and appetite for learning continued to astonish. It included a passion for theology and, though young, he firmly championed the Protestant Reformation that was the main legacy of his reign.

He also inherited his father's taste for competitive martial sports: in the spring of 1551, when he was 13, his diary shows him heading a team of 16 gentlemen 'of my chaumbre' in a varied 'chaleng' to 17 others at Greenwich, including 'running at the ring', a lightweight form of tilting, at the gallop, to spear a suspended ring with the lance. A later re-match entry notes his disappointment when 'My side lost'.

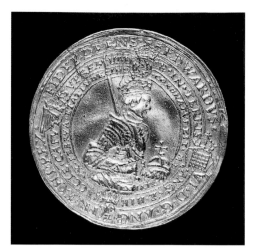

Gold coronation medal of Edward VI by Henry Basse, 1547. Edward was nine when crowned on 20 February 1547.

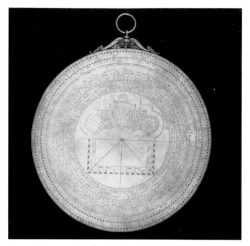

Astrolabe made for Edward VI by Thomas Gemini, c.1552, engraved with Tudor royal arms and emblems.

This was only shortly before he contracted the tuberculosis from which, with other complications, he died at Greenwich on 6 July 1553, aged 15. For a boy who had so far been healthy and active it was a long and painful decline, in which he lost his hair from treatment with arsenic, his appearance changed terribly and his limbs became gangrenous.

To limit knowledge of his condition, his last Lord Protector – John Dudley, Duke of Northumberland – moved him to Old Court, the Greenwich house he then held east of the Palace. In doing so the Duke's ulterior motive was also to conceal exactly when he died: for towards the end, Edward drafted a much-adjusted 'Devise' for the succession that excluded his half-sisters as 'illegitimate', female (and Mary as Catholic) and both at risk of marriage to Catholic foreign princes, in favour of the male issue of his Protestant cousin, Lady Jane Grey. By his death, Jane had been married to one of Northumberland's younger sons, Guilford Dudley – which neither wanted – and had herself become the default option.

The plan was suicidally unreal: Jane was proclaimed queen and lasted nine days until Mary rightfully and at first popularly secured her throne as Edward's heir. Northumberland was executed in August 1553. Jane and Dudley (respectively about 16 and 18) were, for the moment, held in the Tower of London as pawns in a lost game.

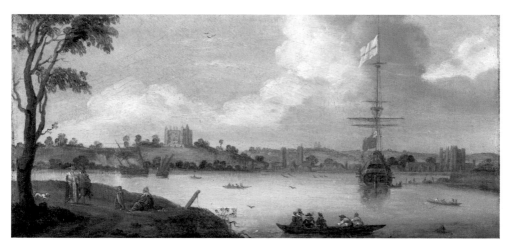

'Greenwich Palace from the North-East with a Man-of-War, about 1630.' *The scale of Greenwich Castle, on the hill, is much exaggerated. Unknown artist.*

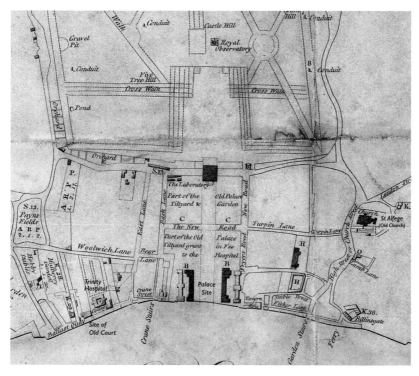

Detail from Samuel Travers's 'Survey of Greenwich, 1695–7', as printed in John Kimbell's account of Greenwich charities, 1816. The title inscription is on p. 41.

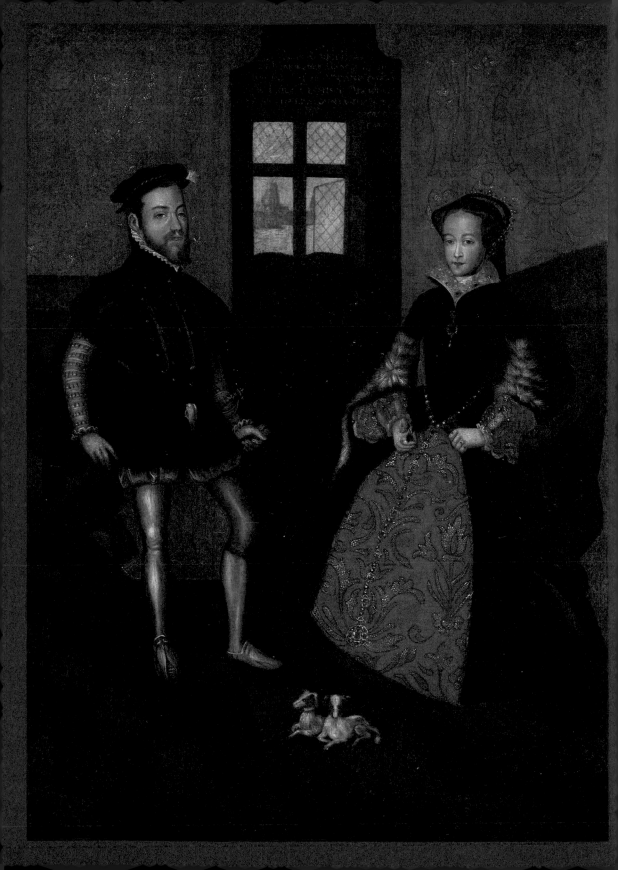

Mary I
(b. 1516, r. 1553–8)

Edward's fears for ongoing Protestant advance in his kingdom were well founded. As English champion of the European Counter-Reformation, his devoutly Roman Catholic elder sister quickly moved to restore papal conformity and allegiance.

Her father's varied plans, since she was two, for her future marriage had not materialised. Now, approving an idea from a former candidate, the Habsburg Emperor Charles V, she agreed a union with his widowed son, Prince Philip of Spain. This sparked an immediate uprising (Wyatt's Rebellion) in which Jane Grey's father, the Duke of Suffolk, was a co-leader; it failed, sealing his daughter's fate and his own. Suffolk, Jane, her husband and two of his brothers were executed in February 1554.

In November the Heresy Acts that Henry VIII and Edward had repealed were reinstated, and from 1555 to

*Mary I, 1516–58, and **Philip II of Spain**, 1527–98. This contemporary painting is a record of the union of dynasties rather than individuals.*

Mary's death in 1558 about 283 people (60 being women) were martyred under them, most burnt at the stake: in other words, every week saw one or more solely sectarian execution. Leading Anglican clergy who died early in the 'Marian Persecution' were Hugh Latimer and Nicholas Ridley – respectively Edward's chaplain and the Bishop of London who had backed 'Queen Jane' – and Thomas Cranmer, the Archbishop of Canterbury who granted Henry VIII's divorce from Mary's mother and thereby long rendered her illegitimate. While the new queen's doctrinal beliefs were sincere, her soubriquet of 'Bloody Mary' was well earned.

Her great reversal at Greenwich was reinstatement of the Franciscan Observant friary, rededicated on 7 April 1555. The queen paid for repair of the brothers' dwelling house but if their church was recommissioned, details are unclear. She also installed two of her mother's former Observant champions there, both driven into exile under her father; Henry Elston as warden, and William Peto. By November 1555 there

were 23 other friars in residence. Peto may have been Mary's personal confessor and she was not pleased when Pope Paul IV made him a cardinal in summer 1557.

Dictatorial Catholicism was by then facing wide resentment, however. In July 1555, Peto and Elston complained of being stoned by local 'lewd persons' when spotted returning to Greenwich from London, while in March 1556 Canterbury was judged too unsafe for the installation of Cardinal Reginald Pole as Mary's new Archbishop: it instead took place at Greenwich on the 22nd. This was the day after his predecessor, Cranmer, had gone to the stake and only two after Pole was ordained as a Catholic priest (from deacon).

Apart from the presumed removal of Protestant trappings in its chapel, there is no evidence that Mary made significant changes to the Palace but she continued to use it. Armour manufacture and tiltyard events also continued there, though with a lower profile than under her father.

Mary was England's first true queen regnant in her own right, but unlike her sister Elizabeth (who must have seen her life as a warning) she was desperate for a male heir to secure Roman Catholic succession. The result, which she drove through against all resistance, was her marriage on 25 July 1554 to Philip of Spain.

It was solely a union of state, between a couple who met only two days before the ceremony (at Winchester) and could only communicate in French and Latin. Its provisions strictly limited Philip's role to nominal King of England and Mary's equally so as Queen of Spain on his accession there in 1556 (when Charles V abdicated to a monastery).

Mary's rapid pregnancy proved an embarrassingly phantom one and Philip left England in 1555, only briefly returning from March to July 1557. She then imagined herself again bearing a child, due in March 1558, which proved worse than false.

From May that year her health rapidly failed, possibly from uterine or similar cancer. Forced to accept her Protestant half-sister Elizabeth as her successor, she died aged 42 at St James's Palace on 17 November. By sheer coincidence Cardinal Pole – the last Roman Catholic Archbishop of Canterbury – followed next day, from 'flu.

'…as of the Manor of East Greenwich…'

From about 1554 in the reign of Edward VI, most general royal grants of land in England stated them to be held 'as of the Manor of East Greenwich in the County of Kent'. This began with Henry VIII's grants from dissolved monastic estates in the 1530s and under Elizabeth I in 1600 it was claimed (with some exaggeration) that 10,000 such awards then existed.

Although 'as of' some other royal manor was occasionally substituted, 'East Greenwich' was by far predominant because Greenwich Palace was the most favoured and used by Henry VIII and his three Tudor heirs. It was therefore where most grants were authorised until Elizabeth I's death. The wording survived long afterwards as a customary formulation, into the early 1700s.

It was also used in early colonial charters, including three for Virginia by James I (1606–12), his New England charter of 1620, and two from Charles I for Massachusetts Bay in 1629 and Maine in 1639. Others under Charles II were for the Carolinas (1663 and 1665), and for the Rhode Island and Providence Plantations in 1663: also his grants to his brother James, Duke of York, for what thereby changed 'New Amsterdam' to 'New York' in 1664, and that for New Jersey in 1674.

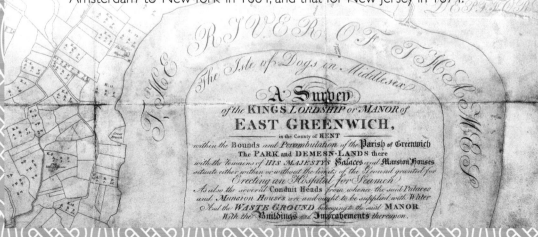

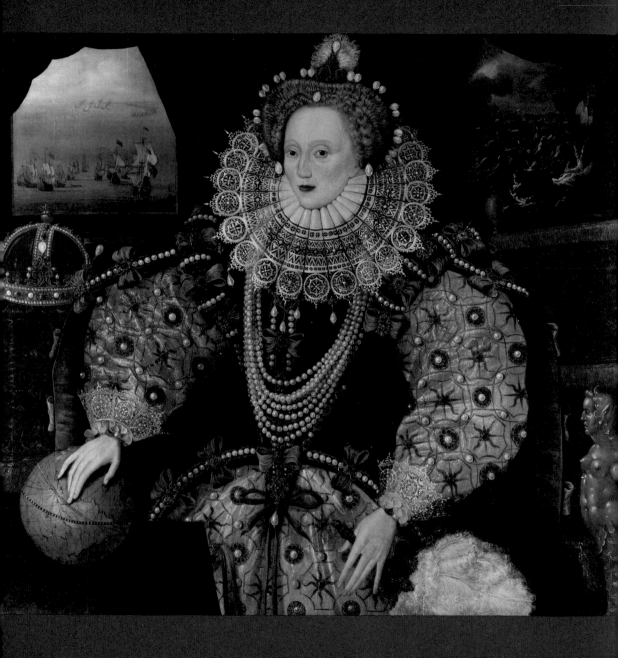

Elizabeth I, 1533–1603 (the 'Armada Portrait'). The best preserved of three surviving versions, marking the key event of the queen's reign. It dates to about 1590.

Elizabeth I
b. 1533, r. 1558–1603

Princess Elizabeth shared the intellectual ability of all three of Henry VIII's children. She can have had no real memory of her mother (executed when she was two) but received good care and a fine education, including in French, Italian, Latin and Greek.

Part of her childhood was spent at Eltham Palace and she certainly knew Greenwich early, although whether she played around the now fallen 'Queen Elizabeth oak' that still lies in the Park is more a tradition than proved (the tree itself dates to about 1300). As queen, however, she often walked daily in the Park and in February 1587 it was there that she was brought papers to sign, including the death warrant of her Catholic second cousin once removed, Mary, Queen of Scots. She did so but instructing her secretary to retain it unsealed: she was furious (and dismissed him) when he passed it to her council, who dispatched it 'from Greenwich, in haste' with the outcome she had long been trying to evade.

The great and linked achievements of Elizabeth's youth were survival and remaining single, at a time when girls of even modest status were seen as marriageable goods to be traded for advantage by their parents or other male relatives. Her mother's path to the scaffold showed her this and 'Queen' Jane Grey's fall in 1553–4 was a more immediate example, not least because Elizabeth herself only narrowly escaped her royal sister's paranoia in its aftermath. In a slightly later phrase on this crisis, 'The Miraculous Preservation of the Lady Elizabeth' was largely owing to her hard-learnt discretion and cool head under questioning.

Ironically, it was her future enemy but then brother-in-law, Philip of Spain, who called off Queen Mary's dogs. He already saw a prospect of using Elizabeth's likely succession as a way of barring the French-backed Mary, Queen of Scots, from supplanting her as next in line.

This required him to marry Elizabeth off to a Habsburg Catholic ally, and though he tried to bully her into accepting one when he last visited England in 1557, she also avoided that until Philip's plan was foiled by her

accession as 'Virgin Queen' regnant on Mary's death. Unsurprisingly, given Mary's marital example, and despite her enjoyment of courtly dalliance (from a position of strength) with handsome young men, Elizabeth thereafter made her single state both a useful tool and the bedrock of her reign.

One of the lessons Elizabeth learnt from her father was that the 'show' of appearing a monarch – in person, portraits and public spectacle – was proof of being one. She could not personally compete in court jousts but made herself their symbolic focus, especially those that soon annually marked her Accession Day (17 November). These were usually held at Whitehall and in them she was represented by a Queen's Champion.

Others occurred at Greenwich, which as well as being her birthplace became her favoured summer residence and place of entertainment. In July 1559, starting the reign with style, 1,400 men of the London 'trained bands' exercised in mock fight before her in the lower Park. She and others of the court reportedly watched from the gallery of the gatehouse spanning the Woolwich Road, later replaced by the Queen's House, of which the south loggia had a similar intended function.

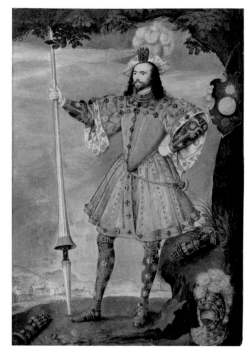

George Clifford, 3rd Earl of Cumberland (1558– 1605), by Nicholas Hilliard, c.1590. It shows him as Queen's Champion in Greenwich armour.

The queen was loudly cheered on thanking those who participated and a few days later further contests of lance and sword took place between three champions and her gentleman pensioners. These were followed by a masque, a feast in a bowery temporary banqueting house, and fireworks and guns shooting until midnight. The possibilities of the river were also exploited. On 23 June (Midsummer Day) in 1561:

> ...at Greenwich there was [a] great triumph on the River against the

Court [in front of the Palace]; there was a fine castle made upon the Thames with men at arms; within it were certain small pinnaces [boats], and great shooting of guns and hurling of balls of wild fire, and there was a platform with two castles for the Queen's grace to be in for to see the pastime, which was very late by the time it was finished.

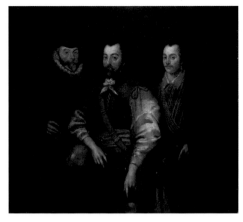

Sir John Hawkins, 1532–95, Sir Francis Drake, 1540–96, and Thomas Cavendish, 1560–92. This is an early copy of a painting probably by Daniel Mytens.

The famous story of Walter Ralegh laying down his cloak for Elizabeth to cross a 'plashy place' is also circumstantially tied to Greenwich in 1582. This incident – a known form of Spanish courtesy – only appears in a second-hand account, probably from Ralegh himself, of how he first caught her attention.

The queen also saw Drake's London departure in the *Pelican* (later renamed *Golden Hind*) from Greenwich Palace,

on what became his circumnavigation of 1577–80, though the practice of passing ships firing salutes had then been stopped after one accidentally put a shot through a Palace window. She also saw Drake's return at Greenwich, prior to feasting and knighting him on board at Deptford dockyard in April 1581.

Detail from Benjamin Wright's London map, 1606. It shows the Golden Hind preserved at Deptford, with Greenwich Palace and the Castle in the Park.

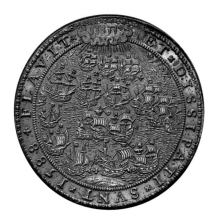

Seaman's astrolabe; a navigational instrument from a wrecked ship of the Armada, found hidden by a survivor under a hillside rock in southern Ireland, in 1845.

Dutch Armada medallion, 1588. The inscription (with 'Jehovah' in Hebrew) surrounds a view of the main battle off Gravelines.

On her instruction the ship was then preserved there as a monument to the voyage: its frame was likened to the bleached skeleton of a horse in 1618 and

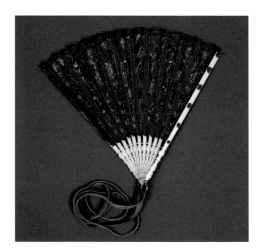

Elizabethan folding fan, late 16th century; a now rare example of the highest quality, such as the queen would have used, from the collection in the Fan Museum, Greenwich.

in the 1660s its remains were cleared, though at least two surviving pieces of furniture were made from the timber.

Later, in November 1588, young Thomas Cavendish (1560–92) arrived home off the Palace from his voyage of circumnavigation and plunder. This time his ship *Desire* came up the Thames not only loaded with Spanish treasure but with sails made of Chinese blue silk-damask, taken from the Manila galleon *Santa Anna*.

When the queen came aboard all the crew had gold chains round their necks and, in remarking that '[Spanish] ships loaded with gold and silver from the Ind[i]-es come hither after all,' she was probably referring to more famous events that summer. For Cavendish returned amid the fading echoes of the 'Invincible Armada', King

Philip's answer to Drake and others' earlier 'singeings' of his beard, as well as being his project to reimpose Catholic rule on the heretical Protestant subjects and sister of his dead queen consort, Mary.

Elizabeth's council planned resistance to the Armada largely at Greenwich, not least in the matter of defending the Thames approaches to London: hence the queen's presence in mid-August to address her troops at Tilbury. It was a defining moment in her reign, even though the main threat had already been averted by the battle off Gravelines, spearheaded by Drake's fireship attack on the anchored Spanish fleet.

As recognised at the time, weather then became a far more lethal Spanish foe as they fled up the North Sea and home round the stormy coasts of Scotland and Ireland. *Flavit Jehovah et Dissipati Sunt* (God blew with his winds, and they were scattered) was the most ringing summation, inscribed on a Dutch commemorative Armada medal.

Elizabeth finally closed the Greenwich friary in June 1559 and its domestic premises became additional lodgings for the Palace. The exposed foundations now visible in the Painted Hall undercroft are probably part of them. While there was no major new building under her, she spent more on Greenwich than any other palace except Whitehall, mostly in renovation and decorative works. In 1567–70 these

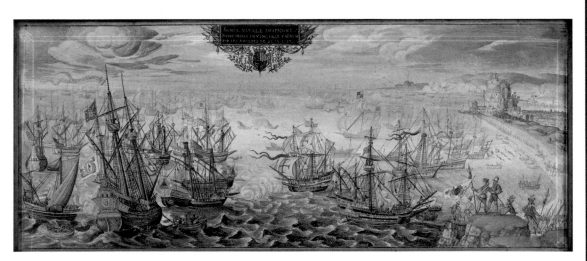

'*The Armada in the Strait of Dover*', *in a rare miniature, c.1610. Lord Howard's flagship* Ark Royal *is in the centre, with Drake's fireship attack in the background.*

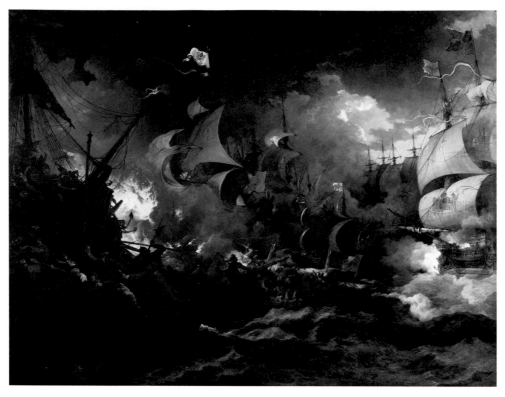

'Defeat of the Spanish Armada, 8 August 1588', by Philippe-Jacques de Loutherbourg, 1796.
A retrospective rendering of the battle off Gravelines after Drake's fireship attack.

included an elaborate fountain in the palace gardens; 1576–8 saw restoration of the tiltyard and 1582–3 a major structural renovation and remodelling of the adjacent banqueting house. Further garden works from 1592 included a second large fountain by her Master Mason, Cornelius Cure (1595–6).

Although little more detail is known of them, Elizabeth's gardens at Greenwich were celebrated, and horticulture played a part in the symbolism of her court. As in all such things she was central to this 'cult of Flora', revelling in its elaborate Platonic flattery but rarely fooled by it. In 1600 the poet John Davies's *Hymnes to Astraea* included a neat acrostic example:

> **E** *mpresse of flowers, tell where away*
> **L** *ies your sweet Court this merry May*
> **I** *n Greenewich garden allies [alleys]?*
> **S** *ince there the heavenly powers do play*
> **A** *nd haunt no other vallies.*

Paul Hentzner, a German visitor, left a more objective and detailed portrait of the ageing queen when he saw her in crowded public presence at Greenwich Palace in 1598:

...in the sixty-fifth year of her age we were told, very majestic; her face oblong, fair, but wrinkled; her eyes small, yet black and pleasant; her nose a little hooked; her lips narrow, and her teeth black (a defect that the English seem subject to, for their too great use of sugar) ... she wore false hair, and that red; upon her head she had a small crown ... Her bosom was uncovered, as all English ladies have it till they marry; and she had a necklace of exceeding fine jewels; her hands were small, her fingers long, and her stature neither tall nor low; her air was stately, her manner of speaking mild and obliging ... As she went along in all this state and magnificence she spoke very graciously, first to one, then to another... Whoever speaks to her, it is kneeling... Wherever she turned her face, as she was going along, everybody fell down on their knees.

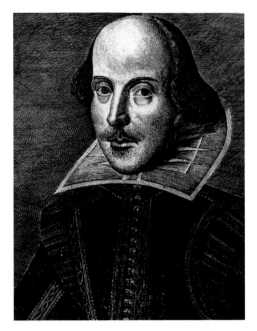

William Shakespeare. *Martin Droeshout's print from the first folio edition of the complete works, 1623.*

Shakespeare (1564–1616) was writing *Measure for Measure* and *Othello* about the time the queen died, aged 69, at Richmond in 1603. The earliest record of him in a theatre company is at Christmas 1594, as one of the three payees for the newly formed Lord Chamberlain's Men when they twice performed before her at Greenwich Palace: its leading actors Richard Burbage and Will Kempe were the other two. What they played is unknown but their presence at Greenwich alone links it into the wider fame of the Elizabethan age.

49

Greenwich Castle

It is not certain if the watch tower on Greenwich hill that Duke Humphrey of Gloucester gained permission to crenellate in 1433 was one he built, or one already there that he improved as a hunting lodge. In 1525–6 Henry VIII 'newly repaired and builded', or rebuilt, it and reportedly lodged 'a fayre lady whom [he] loved' there. Its ornamental, turreted form soon earned it the name 'Greenwich Castle' and the hill 'Castle Hill' (as today, though little used).

By Elizabeth I's reign it was also called 'Mirefleur' which may allude to the walled garden around it. In 1605 James I granted it to one of his supporters, the wealthy Henry Howard, Earl of Northampton (d. 1614). In the last year of his life he was official Keeper of the Park and remains of his tomb (originally in Dover Castle), including his kneeling effigy, are now in Trinity Hospital, Greenwich, one of three almshouses founded under his will and still flourishing.

Ad ripas Grenovica tuas, hic THAMESIS unda
Alluit Angligenum Regalia tecta Monarchæ.
Quæ situs quæ forma, decusq virentia septa
Concelebrant totum longe lateq per orbem,
Behould, by Prospect, with what Art
Fayre Greenwich Castle, pleasantly.
A House of Banquet, neare & part;
Of Thames, and London how they ly.

Though small, the Castle was a three-storey building of well-proportioned rooms. An inventory of 1614 shows its upper floor held a richly decorated bedchamber, a 'palatte chamber' (servant's room), closet and gallery. The middle floor had 'great' and 'withdrawing' chambers and a wardrobe; the ground floor had a hall, four servants' rooms, and there was also a kitchen and wine cellar. A leaded and accessible flat roof gave a magnificent view over London and the upper turret had a pyramidal roof topped by a painted and gilded weathervane.

In 1633, Katherine, Countess of Suffolk, died at the Castle but when the Royalist sympathies of Greenwich led Parliament to put troops there early in the Civil War, it was despoiled and became derelict. It seems to have been largely demolished before final levelling to erect the Royal Observatory on its foundations in 1675. John Flamsteed (1646–1719), the first Astronomer Royal, complained about this since it meant the new building was not aligned 'meridianly' (due north and south) for altitude-observation quadrants to be mounted on its walls. He instead had to build a small 'meridian observatory' for his main quadrant in the garden behind.

Greenwich Castle, looking down on the town and tower of old St. Alfege Church. Detail from Hollar's panorama (pp. 58-59), 1637.

London

HOUSE OF STUART

Painted about 1696, this view shows Webb's 1660s new palace wing
by the river, with the Queen's House, Park, Royal Observatory and
John Flamsteed's 60-foot refracting mast-telescope. Unknown artist.

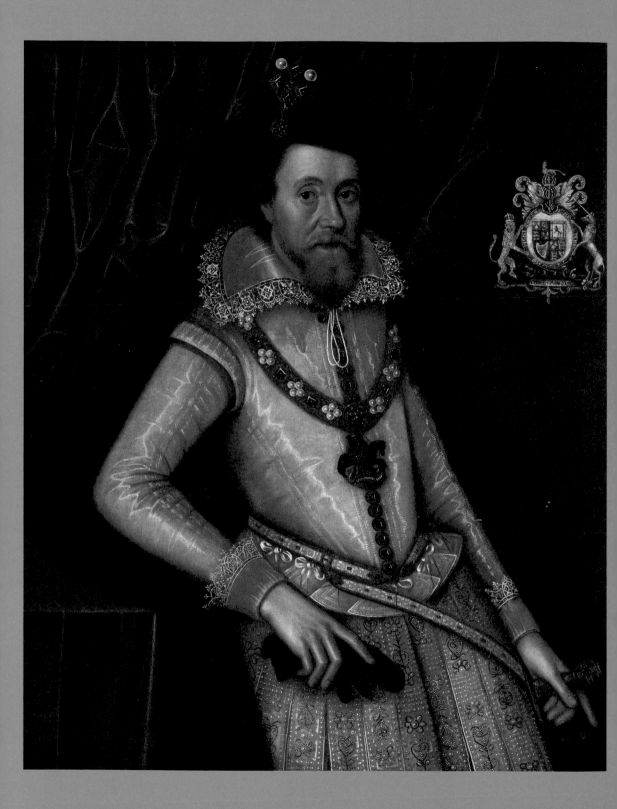

James VI and I
b. 1566: r. in Scotland, 1567–1625; in England, 1603–25

On Elizabeth's death, royal succession passed back and sideways via Margaret Tudor (Henry VIII's elder sister), who had married James V of Scotland. Their only surviving child was Mary (1542–87) who, by her father's death from fever, became Queen of Scots at the age of only six days. Raised a Roman Catholic and mainly in France, Mary thereby became the childless Queen Elizabeth's closest heir from 1558 and her son James next in line.

His father was her second husband, Henry Stuart, Lord Darnley, who was murdered in 1567, probably by agents of her third, the Earl of Bothwell. Mary last saw James at ten months old: two months later, in July 1567, he inherited her Scottish crown, as James VI, when she was forced to abdicate.

In 1568 she fled south to seek help from her Protestant cousin Elizabeth but that proved a mistake. As both Catholic

James VI and I (1566–1625), about 1610, by John de Critz. A standard image by James's 'serjeant painter'.

and presumptive heir in England, around whom Elizabeth's enemies could rally, Mary's very existence was a threat. She was soon under 20-year English house arrest, in many places and through various plots involving her, before Elizabeth reluctantly approved her execution in 1587.

James VI of Scotland was raised a Protestant. His 1603 accession as James I of England as well – a union of crowns but not of parliaments until 1707 – was skilfully and smoothly managed, although he faced two serious later conspiracies: of these the Gunpowder Plot of 1605 is best remembered.

His personality and image were relatively low key but he was a careful ruler, who worked to unite both his kingdoms in more than just crowns. He was also a serious and scholarly monarch: his publications included a polemic against tobacco, important works on kingship and, as a ruthless enemy of witchcraft, a *Demonologie*.

Alongside the literary giants of his reign, including Shakespeare, Ben Jonson and John Donne, his major

Henry Frederick, Prince of Wales (1594–1612) by Robert Peake, Charles II's elder brother.

bringing her over was driven back to Norway by storms and his expedition to retrieve her, including their formal marriage in Oslo Cathedral, has been called 'the one romantic episode of his life'. It was a successful union but with only three surviving children: Henry Frederick, Prince of Wales, who was hailed as a paragon of princely virtue by the time he died of typhoid aged 18 in 1612; Charles (his father's successor), and Elizabeth (1596–1662), later 'Winter Queen' of Bohemia and link to the Hanoverian succession in 1714.

Early Stuart involvement at Greenwich largely centred round Queen Anne and, in the next reign, her daughter-in-law, Henrietta Maria. Palace improvements, many for Anne, were considerable. James underpinned the Tudor hall with its still-surviving undercroft in 1604, added a two-storey lodging range on the Park side in 1609–11, and in 1615–16 extended the Queen's Lodgings with 'new brickwork towards the garden', including a Classical ground-level stone loggia by the Surveyor of the King's Works, Simon Basil. The gardens were also remodelled for her by the internationally celebrated Salomon de Caus, including fountains, statuary, a grotto and an aviary.

contribution – as its sponsor – was the Authorised or 'King James' translation of the Bible, published in 1611. He was also a peacemaker, bringing the long war with Spain to an end in 1604 and avoiding foreign military adventures.

In 1589 James made a proxy marriage with Princess Anne – strictly Anna – of Denmark (1574–1619). The convoy

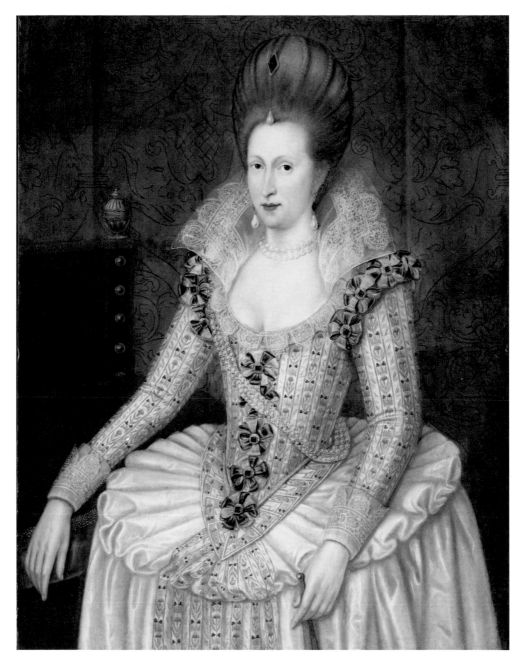

Queen Anne (*Anna of Denmark, 1574–1619*), *by John de Critz. A standard-pattern portrait of about 1605, originally accompanying one of her husband James I, similar to that on p. 54.*

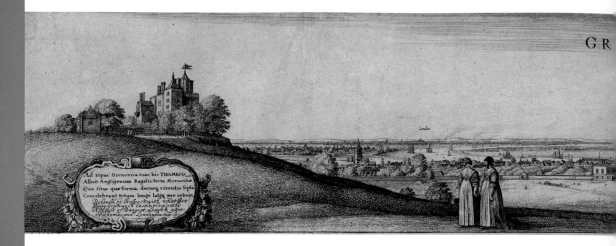

In 1613 the king formally granted her the whole manor, including Palace and Park. A leader in fashion and the arts, Anne shared her husband's enthusiasm for the hunt and he reportedly made the gift (as well as that of a costly diamond) in apology for swearing at her after she accidentally shot 'Jewel', his favourite hound, in the course of one. By this time, although still on terms of affectionate respect, they had grown apart and had separate courts, often vying with each other: in this Greenwich provided a new stage on which the queen could make her mark.

The most distinctive court entertainments of the day were masques; emblematic, classically inspired dramas to praise the monarchy as an earthly reflection of heaven, and show the triumph of virtue over vice. They combined elaborate scenic effects and costumes, music, dance, and members of the court representing the virtuous figures.

Although they began earlier, the scenic master of the form under James I and Charles I was Inigo Jones (1573–1652), working to 1631 with the playwright Ben Jonson, then with others to 1640. Their first collaboration, devised for Queen Anne and in which she participated, was *The Masque of Blackness* at Whitehall in 1605. Most took place there with James as their royal focus, eventually in the new and surviving Banqueting House (1619–22) that Jones built largely for the purpose. On 4 May 1617, however, and as the last masque in which Anne participated, while James was in Scotland she was central

'Graenwich' in 1637. This etching is Wenceslaus Hollar's earliest London view. It shows the brand-new Queen's House against its backdrop of the Palace and tiltyard, with Greenwich Castle on the left.

to Robert White's *Cupid's Banishment*. This was 'Presented to Her Maiesty/ By younge Gentlewomen of the Ladies Hall [school]/in Deptford/at Greenwich'. Unfortunately, whether it was in the hall of the Palace or the old disguising house is unclear, since no production details survive.

Jones also had early architectural skills, exercised before 1612 only a little as Surveyor to Prince Henry. In November 1614 he returned from a long study of Classical and Renaissance buildings in Italy and the following year succeeded Simon Basil as royal Surveyor.

In 1616, commissioned by Anne, his first major project was the Queen's House at Greenwich, which replaced the Tudor gatehouse between the Palace and Park, bridging the Woolwich road. While not finished until the 1630s, it was also the first fully Classical building designed in England and set the style for everything that followed on the old Palace site. Seen from high in the Park as a simple white, geometric form against its rambling red-brick backdrop, the House must have first appeared far more alien than just a 'curious devise of Inigo Jones', as a courtier called it when just under way in June 1617.

Because the Woolwich road was moved north to its present position in about 1697–9, it is easy to assume that the House has always 'faced' the river, from which the Palace entirely blocked its

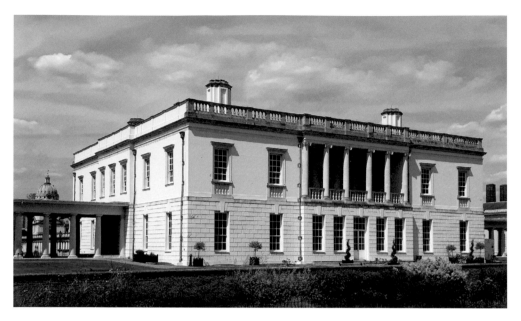

The south façade of the Queen's House today. This is the front of the building as originally designed, when it looked directly onto the Park

view until the 1660s. The original 'front' is the south side, from which Jones first conceived it to be seen, in direct southern sunlight from the hill and Park. That side includes the elegant, columned first-floor loggia, making the whole House a 'frontispiece' intended to stamp Anne's identity on the Tudor complex behind.

She did not live to enjoy this affirmation: work stopped just before she fell ill in 1618, with only the separate, ground-floor brick storeys up on either side of the road but probably connected by the paired arch-spans of their central bridge. Anne died in March 1619 and

while King James began walling the Park in that year (see p.14), the half-height shells of her villa were just thatched over against the weather until about 1632.

Jones's last works for James at Greenwich in 1623–4 were interior remodelling of the Palace chapel and a 'fayre great gate' to the Park, which he inserted in the roadway south wall, west of his only part-built 'curious devise'.

Inigo Jones, 1573–1652, by William Hogarth after Van Dyck, 1757. The Queen's House was Jones's most significant work, as the first fully Classical building in Britain.

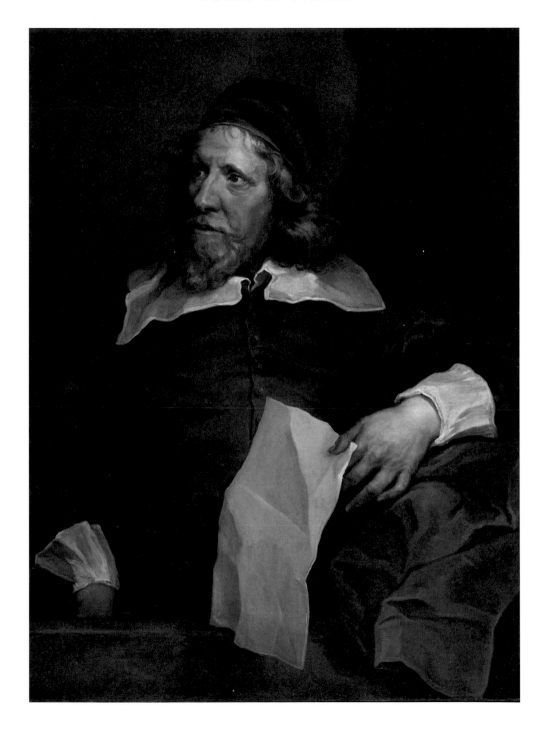

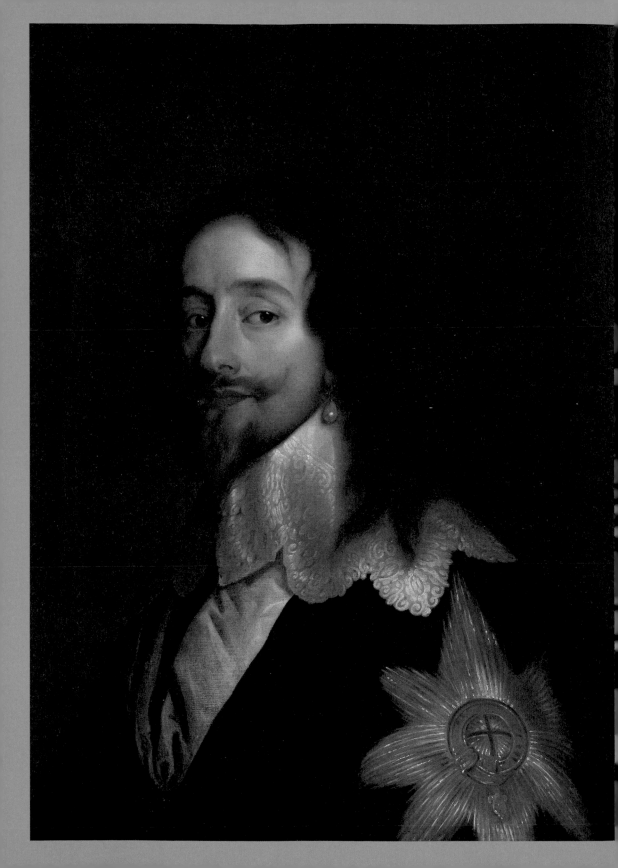

Charles I
b. 1600, r. 1625–49

Charles succeeded his father in March 1625. Had his elder brother Henry, Prince of Wales, lived to do so, British history might have been different. Henry seems to have been physically and intellectually impressive: Charles was not the former, though it is well disguised (as for his buck-toothed queen, Henrietta Maria) in the work of their great court painter, Anthony Van Dyck.

His fatal conviction was belief in the mystical, divine right of kings as answerable only to God, on which – and on their duty – his father had written seriously and which Charles took equally so. In terms of personality his other trait was a stubborn, Stuart inflexibility that would later also bring down his younger son, James II; the elder, Charles II, was a more intelligently pliable master of political survival. Their father's unarguable distinction was as the greatest connoisseur of the visual

Charles I (1600–49), after Van Dyck. The pearl earring is reputedly the one Charles was wearing when he walked to execution in 1649.

arts ever to occupy the British throne, a field in which only George IV later approached him.

Charles I's reign can thus be seen in two different strands. One was a story of political and religious stand-off between an autocratic 'high-Church' king and a dissident Puritan parliament: this first produced mounting resentment both to his policies and his exactions to pay for them without general consent, then civil war and his death. The other is of royal art patronage and collecting on an international scale.

Prime example was Charles's mass purchase (from 1627) of the collection of the Gonzaga dukes of Mantua: it cost just over £28,000, or about £3.5 million now, but £300 million conveys a better idea in recent 'art-inflation' terms. While such extravagance roused Puritan ire, in the words of the modern Royal Collection it 'transformed the quality and depth of the British holdings wholesale'. The tally of old-master paintings and antique sculpture ran into hundreds, including Mantegna's vast *Triumphs of Caesar*, and Charles already had Raphael's surviving

63

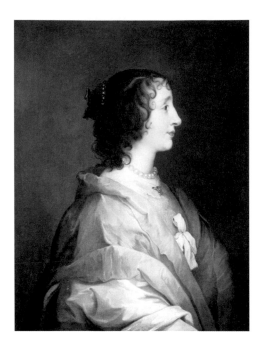

Queen Henrietta Maria (1609–69);
studio of Sir Anthony Van Dyck. This may
have been painted for the queen's Lady of
the Bedchamber, the Countess of Denbigh.

1630s, however, they adorned the royal palaces and Greenwich had a large share, including paintings and sculpture in the Queen's House. Curiously, however, the only paintings owned by Charles I now permanently at Greenwich (in the NMM) are a set that he had given away, showing the Turkish siege of Malta in 1565.

Charles married Henrietta Maria, sister of Louis XIII of France, shortly after his accession in 1625, and she was officially known as Queen Mary in England. Her pious Roman Catholicism automatically made her a figure of suspicion and her loyalty to Charles more so, as his star waned. It began, of course, as a dynastic match and they only became close after the murder of his favourite, the Duke of Buckingham, in 1628.

Greenwich Palace was then still a royal residence also in diplomatic use. In May 1629, with much ambassadorial ceremony, a peace with France was proclaimed by 'trumpet and four heralds at Greenwiche in the conduyte [Conduit] court the Kyng and Queene in a window of the gallery... privately beholding the manner of yt'. In that year Charles, like his father, vested the manor on his wife, as part of a delayed marriage settlement, and it became her habit to spend spring months there.

cartoons for work in the Vatican, which he bought in Genoa in 1623.

From September 1649, after his execution, these parallel stories of kingly downfall and artistic accumulation combined into a finale of bottom-line Puritanical asset-stripping, as Parliament sold off all 'the late King's goods' for what it could get. While Charles II recovered some of these treasures, many that he did not are today in museums and galleries round the world. In the

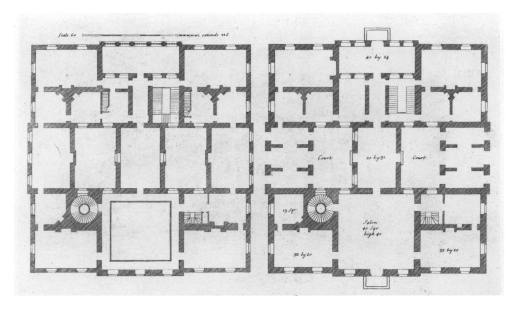

Upper (left) and ground floors of the Queen's House from Colen Campbell's Vitruvius Britannicus *(vol. I, 1715). The south (Park) side is at the top.*

Inigo Jones resumed work on the Queen's House for her by 1632 but with some changes. Fashionable garden design had advanced from the tall, maze-like planting, statuary and other structures of the early part of the century. Charles brought in French gardeners to work at other palaces and, at Greenwich, they probably also remodelled the Queen's Garden south of her existing Palace lodgings to low-level, formal parterres in French style.

These were best seen from above and, as the House advanced, she presumably confirmed that her bed chamber and withdrawing room would overlook them on the Palace side. As first completed – and possibly not among Jones's 1616 intentions – both these rooms had two iron balconies linking their paired northern windows. A dated plaque bearing the queen's name was also set above the centre top window between them to mark the building's structural completion in 1635.

These 1630s adjustments made the House a more inward-looking, Palace-facing retreat – a 'secret' garden house for the queen and her intimate circle. The greatest external change was that

in or after 1635 Jones also added the balustraded north terrace and its paired curved stairs. These were not part of his 1616 design and the lower steps were originally closely facing each other, until cut back to a more open horseshoe form around 1713.

As an extension from the 40-foot single-cube hall, the terrace gave a fine summer viewpoint over the new gardens, with direct access to them. It also strengthened what had originally been the rear elevation of the House, as did a recorded possible intention to decorate it with a Mannerist design similar to that in the ceiling coving of the Queen's Bedchamber immediately behind, on the top floor.

Now believed to be by Edward Pearce, a frequent collaborator with Jones, the Bedchamber ceiling is the only original painted decoration in the

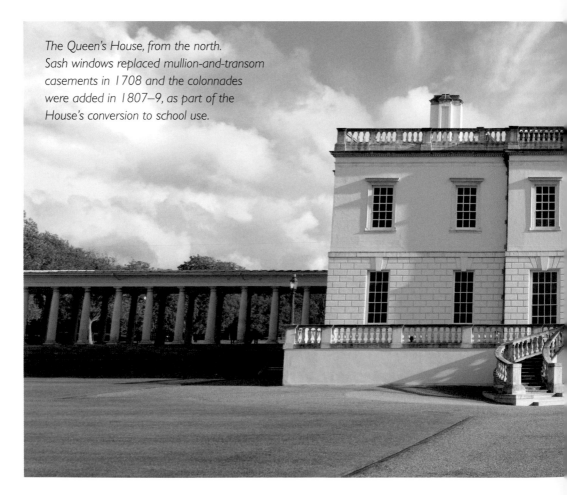

The Queen's House, from the north. Sash windows replaced mullion-and-transom casements in 1708 and the colonnades were added in 1807–9, as part of the House's conversion to school use.

building other than the gold and white Hall woodwork: those were the royal French colours but time has degraded the white to a murky green, under many later layers stripped off in the 1930s. The House was internally finished about 1638 and paintings commissioned for it – not all delivered – included Orazio Gentileschi's nine panels of *Peace surrounded by the Muses and Liberal Arts* in the Hall ceiling (now in Marlborough House, London). Others were drawn from Charles I's collection and ten antique statues, probably from the Gonzaga purchase, were also set up on 'Roman altar' wooden plinths in the Hall.

While nothing is known of the House's first use, it still gained a reputation that survived the later Parliamentary pillage of its contents. Writing in 1659, the antiquary Thomas Philipott called it that 'house of delight, towards the park,

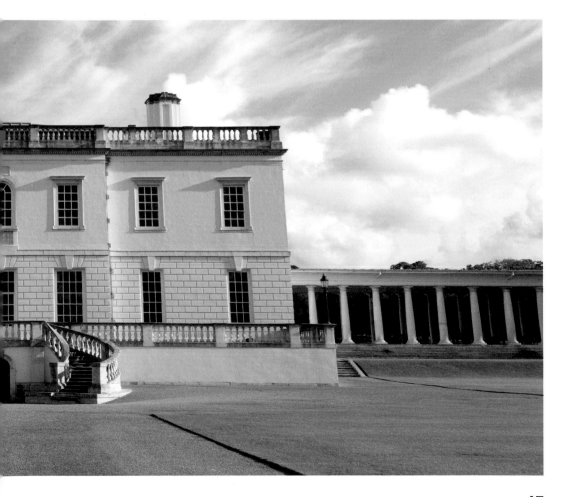

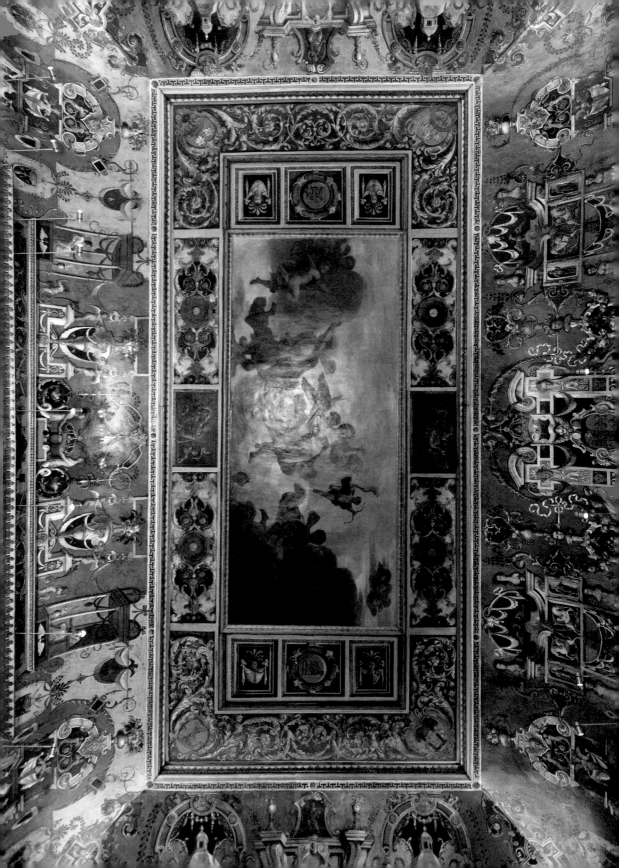

Engraved silver counter commemorating Charles I and Henrietta Maria. Their royal arms are on the reverse. It may date from the 1700s but nothing else is known about it.

Greenwich bedchamber pairs her royal arms and husband's within an unusual heart shape, above the bed position, and includes a Latin allusion to their 'mutual fruitfulness' as the 'hope of the state'.

The early Caroline idyll of which Henrietta Maria was fashionable leader and royal figurehead at Greenwich proved short. Both king and queen were last there in September 1642, before she took Princess Mary to marry the Prince of Orange in Holland and raise money for her husband's cause. They last saw each other in 1644 at Abingdon, early in the Civil War (1642–51), when the queen – again pregnant – left for safety in the West Country: her last child, Henrietta (later Duchess of Orleans), was born at Exeter.

which Queen Mary, had so finished and furnished, that it far surpasseth all other of that kind in England.'

The years of its completion and shortly after were also those in which the queen had her children (1629–44): apart from Charles (first survivor, b. 1630) and James (b. 1633), the other one relevant here was Mary (b. 1631), mother of William III. Appropriately, the painted ceiling in the Queen's

She then escaped to France, only briefly returning to live in England, 1662–5, of which just the first few weeks were at Greenwich. Charles I's reign ended under the headsman's axe on 30 January 1649, on a scaffold in front of Inigo Jones's Banqueting House at Whitehall: 'Queen Mary' died in France twenty years later.

The Queen's Bedchamber ceiling; the 1630s decorative coving is now thought to be by Edward Pearce. The central painting is an early 18th-century one of uncertain origin.

69

The Commonwealth

1649–60

During these eleven years, monarchy was abolished and replaced by a Parliamentary republic. In practice, it was a military regime directed by Oliver Cromwell, leading Puritan general of the New Model Army. He was formally appointed Lord Protector from 1653 to his death in September 1658, with powers similar to a personal-rule king. Cromwell strengthened the Navy, most of which had long sided with Parliament, and pursued an aggressive policy to expand sea trade and secure colonies, which led to conflict with the Dutch and the Spanish, who later backed the exiled Charles II. By 1652 he also gained control of Ireland and of Scotland, where Charles lost the Scottish crown to which he had been anointed at Scone Abbey on 1 January 1651.

Oliver Cromwell (1599–1658).
The head in this 18th-century oil portrait copies a miniature by Samuel Cooper, the armoured body that of another sitter by Van Dyck.

Most of the royal land at Greenwich remained in state hands and/or was later retrieved by Charles II. The old Palace was used during the First Dutch War (1652–4) to house naval prisoners and also as a biscuit factory. Although the Queen's House was reserved for Cromwell's use he did not take this up but two of the Parliamentary Generals-at-Sea lay in state there: Richard Deane after his death in action against the Dutch in 1653 and the great Robert Blake in 1657. Also in 1657, Parliament

invited Cromwell to take the Crown. He refused but, on his death, his son Richard was installed as hereditary Lord Protector. Richard neither sought the post nor had the qualities it required, which soon led to army dissatisfaction with him and the unrest surrounding his resignation in 1659.

With sentiment turning toward restoration of the Stuart monarchy, General George Monck, Governor of Scotland, steadied the situation by marching his army to London and became the main agent in negotiating terms with Charles II on behalf of the 1660 Convention Parliament. They precluded general vengeance, except against the fifty 'regicides' who had signed Charles I's death warrant. In the event, only nine of these were even more brutally executed: so, with posthumous gruesomeness, were the exhumed corpses of Cromwell and a few others. One Greenwich regicide was among those hanged, drawn and quartered: this was the merchant and MP, Gregory Clement (1594–1660), who in the 1650s completed the fine riverside dwelling later called Crowley House (demolished 1855), on the site of Greenwich Power Station.

Britain's experiment in Puritan republicanism died amid few regrets in May 1660: Charles II returned to London from Holland on the 29th, both his thirtieth birthday and commemorative day of restoration (Oak-Apple Day). He himself, and all his official Acts, dated his reign from the death of his father in 1649.

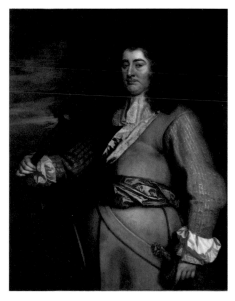

George Monck, 1st Duke of Albemarle (1608–70), by Sir Peter Lely, 1665–6. Monck began as Royalist but later became a Parliamentary general.

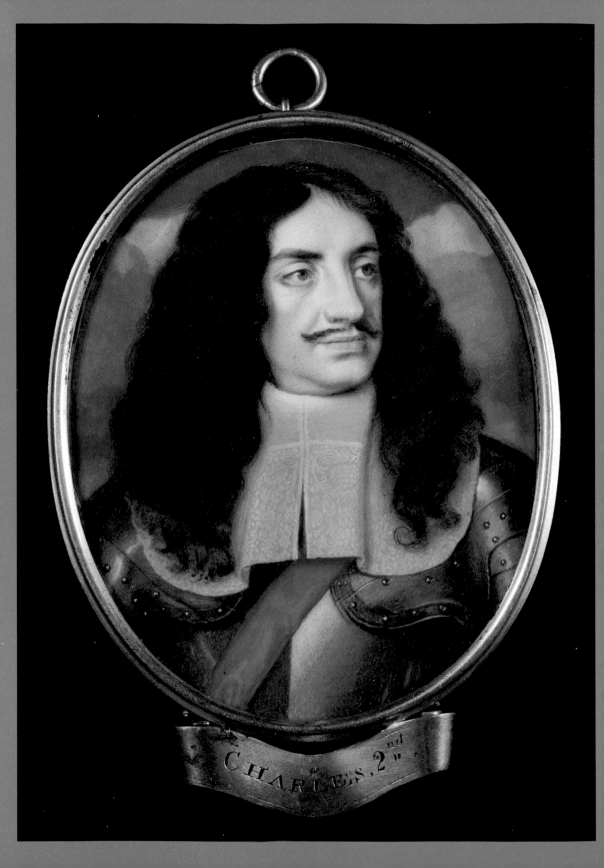

CHARLES. 2ᵈ

Charles II
b. 1630, r. Scotland 1649–51: restored, 1660–85

Six of Charles I's children survived infancy but grew up in the years before and during the Civil War (1642–51): all were shaped by this and the fate of their father. Earlier kings had died in battle or been murdered: none had faced state trial and public execution as he did, in a process that changed the understanding of treason from betrayal of the Crown as embodying the state to the Crown betraying its subjects as represented by Parliament.

Both Princes Charles and James stayed with their father until 1646 but reached adulthood in exile, in France and later the Netherlands. Despite endless shifts for money both learnt dissolute habits there, which Charles imported into his later reign as England's pleasure-loving 'merry monarch'. James Scott, later Duke of Monmouth and eldest of his twelve acknowledged illegitimate children, was born at Rotterdam in April 1649, ten weeks after Charles I's death.

Charles II (1630–85). This miniature by Samuel Cooper shows him in the early 1660s.

Neither of the younger Stuarts lacked courage. Both were at the Battle of Edge Hill in 1643 and in 1651 Charles led a Scottish Royalist army south: his defeat by Cromwell at Worcester on 3 September ended the Civil War. Charles's subsequent escape to France is legendary, mainly for his episode of hiding in an oak tree, but not least since the main source of details is his own self-deprecating account.

After his restoration, Charles effected a revolution on the landscape at Greenwich. In 1661–2, ahead of the long-term return of his widowed mother, Henrietta Maria, he first adapted the Queen's House for her by adding two 'bridge rooms', to east and west of the original central one over the Woolwich road. This converted the building from an 'H'-plan with queen's apartments on the north side, to one with a fully connected upper floor of 'King's Side' to the east and 'Queen's Side' to west.

Her old bedchamber became a Presence Chamber, the most public of the western sequence, leading through to a new bedchamber overlooking the

Park, west of Jones's columned first-floor loggia. The intention was that the queen live at Greenwich until Somerset House was ready for her but she only stayed a few weeks, from July to September 1662, until preferring to go there despite ongoing site work to 1665.

This was unsurprising: Greenwich had much changed and her memories cannot have been happy. While there however, in July 1662, she first met Charles's new queen, Catherine of Braganza: they had married at Portsmouth in May and in 1670, after his mother's death, Charles gave her the manor of Greenwich.

Charles began a huge programme of tree-planting in the Park in 1661, including re-landscaping the area south of the Queen's House to its present form of raised avenues flanking a central parterre. As Samuel Pepys noted in his diary in April 1662, he had then also 'made steps in the hill up to the Castle, which is very magnificent', but it would all have taken time to finish and bed in.

The formerly pretty Castle was itself by then ruinous and so, increasingly, was the old Palace. The king already had plans for its entire replacement and in 1662 demolition started but lasted over thirty years. During that time the

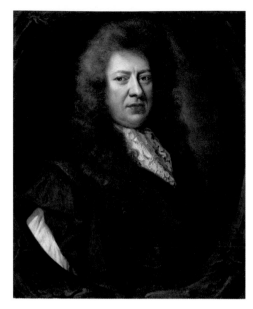

Samuel Pepys (1633–1703), by Sir Godfrey Kneller, 1689. Pepys kept his famous diary only early in his career as a naval official, from the Restoration in 1660 to 1669.

House looked north over still-used parts, temporary buildings and broken walls, albeit soon gaining its first view of the river. When Pepys and the Navy Office left London for safety in the year of the Great Plague (1665), they probably used space on the east side of the Palace, where the Tudor hall was only demolished in 1686, and the Chapel in 1699.

This slightly unfinished 'Exact Plan of Greenwich Park' by the gardener Henry Wise probably dates to the early 1700s but Romney Road (built c.1697–9) is not included.

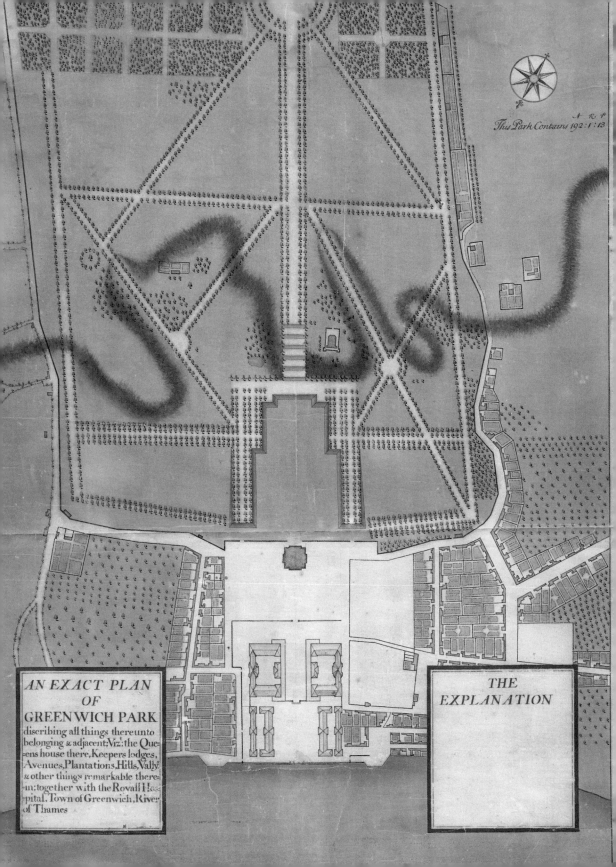

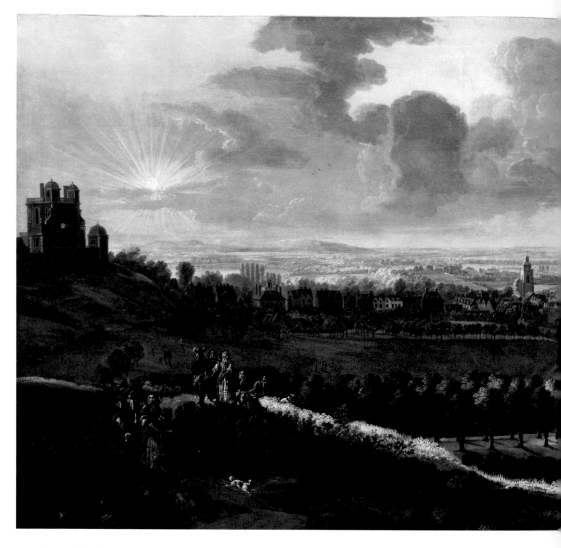

On 4 March 1664 Pepys had been at Greenwich and noted 'the foundacion laying of a very great house for the King, which will cost a great deal of money': by November 1665 it was over £75,000. This was the start, on the western side, of Charles's new palace.

It was mainly designed by Jones's pupil and son-in-law John Webb, but by 1670 work had stalled, leaving just a single, long range, which is now the eastern side of the King Charles Court. It remained isolated, windowless and only notably used as a gunpowder store,

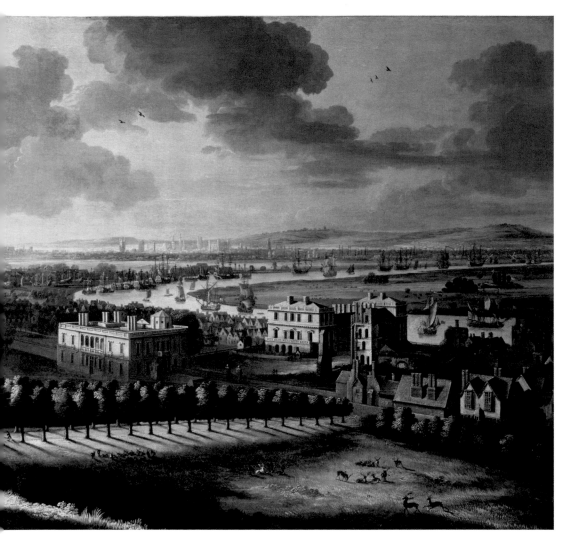

until incorporated in Wren's design for Greenwich Hospital in the 1690s.

Gunfire was also occasionally heard at Greenwich in Charles's reign. The tiltyard became a 'firework' testing ground and Charles himself oversaw artillery experiments in which explosive 'grenadoes'

'Greenwich and London from One Tree Hill, in the 1680s', *by Johannes Vorsterman, showing the Queen's House, the unfinished 1660s wing of Charles II's new palace and the Royal Observatory.*

77

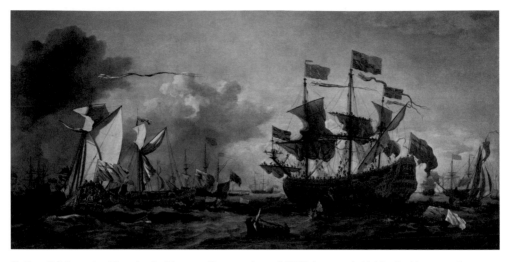

'*A Royal Visit to the Fleet in the Thames Estuary, June 1672*', *by van de Velde the Younger, showing Charles II's visit to his brother James's flagship,* Prince, *after the Battle of Solebay. Two royal yachts are on the left.*

were fired from outside the Queen's House at Castle Hill. On 2 June 1666, during the Four Days Battle in the Second Dutch War, Pepys reported that in the Park, 'we could hear the guns of the fleete most plainly' borne in on the east wind; and how the King and his brother James, Duke of York, also came 'down in their barge to Greenwich-house' and 'went up to the park to hear the guns of the fleete go off'.

Charles and James – who was his brother's Lord High Admiral to 1673 – both acquired the Dutch taste for yachting while in exile there. The Dutch gave Charles a yacht, the *Mary*, at his Restoration and the Navy was soon building English designs at Deptford and Woolwich dockyards for royal and other naval use. At Greenwich the Palace (later Hospital) site became the normal royal embarkation point in their use from then on, into the nineteenth century. By 1661 James and Charles were sailing home-built examples competitively and on 1 October that year John Evelyn joined the king on a new 'frigate-like' one in which he raced James's from Greenwich to Gravesend and back for a wager of £100: James won the outward leg but the king 'saved stakes returning … sometimes steering himself'.

Charles also introduced another Dutch nautical taste into British culture: that for the marine painting, which was specifically imported through Greenwich. In 1672, when the Third Dutch War was going badly for them, he issued a general invitation for Dutch artists and craftsmen to settle in England. The most distinguished painters who permanently did so were the Willem van de Veldes, father and son. The father was a celebrated marine draughtsman, already long employed by the Dutch provincial Admiralties to record their ships and battles, and his son an even better painter of them.

Charles retained them both to do the same for him at £100 a year each and also gave them the south-west ground-floor room in the Queen's House as their studio. From early 1673 they worked there for about eighteen years, living two streets to the east, but moved to Westminster in 1691: Willem the elder died there in 1693 and his son in 1707. Today the NMM collection at Greenwich includes the world's finest holding of their work, that of many of their contemporaries, and of the native British marine painters to whom they first provided example. At least a few pictures by them usually hang in the room where many were painted.

'The 'Royal Escape'', by Willem van de Velde the Younger. The former Sussex collier, Surprise, in which Charles escaped to France in 1651.

Such 'grace-and-favour' uses of the House began after Henrietta Maria's departure as last royal tenant. In the later 1660s and 1690s Russian envoys were temporarily accommodated there. In between, other residents included French Huguenot refugees. One was Sir John (Jean) Chardin, eastern traveller and court jeweller to Charles II; another was the old Marquis de R[o]uvigny, who had been French ambassador to Charles in the mid 1670s and died at Greenwich in 1689. Jane Middleton, one of the Charles's lesser paramours, was also reportedly lodged there.

Charles II's most significant monument – for those who recognise the reasons – stands on Castle Hill in the Park. It embodies both his scientific interests and his support for the expansion of British sea power and seaborne trade.

The king's 'nautical literacy' was more than that of a keen amateur yachtsman. He and the navally competent men advising him, including his brother James, his cousin Prince Rupert of the

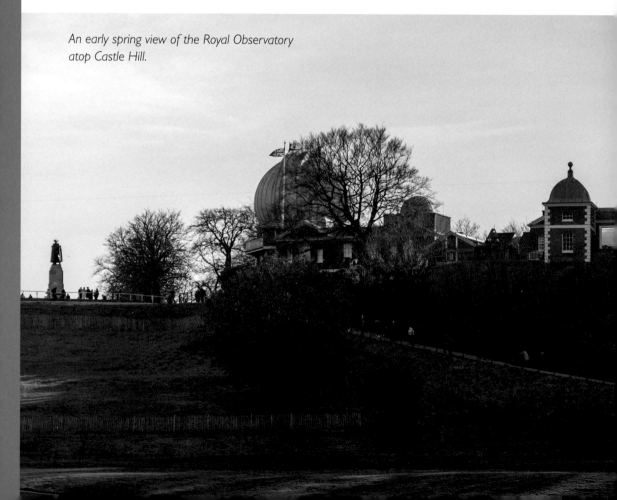

An early spring view of the Royal Observatory atop Castle Hill.

Rhine, and Samuel Pepys (eventually Secretary of the Admiralty), understood both the potential and limitations of ships and seafaring. In 1660, the year of his restoration, Charles was also founder-patron of the Royal Society of London, whose purpose was to develop science – then called 'natural philosophy' – by observational and experimental means.

Navigation at sea, above all the unsolved problem of calculating accurate longitude (east-west distances), was an issue incurring huge costs in lost lives,

ships and cargoes at that time. Theoretical improvements were envisaged but required better methods of position-fixing by astronomical means. That required accurate star-charts and related tables, as well as advances in observational technology to make and use them. It also required a place dedicated to undertaking the years of necessary observation, recording and calculating work, and staff to do it.

In March 1675, Charles appointed the 31-year-old Revd John Flamsteed as his first Astronomer Royal. Then in

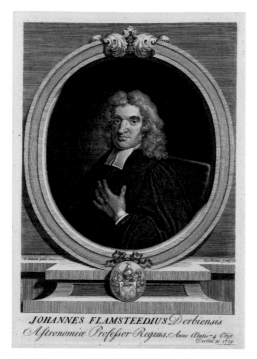

John Flamsteed (1646–1719), the first Astronomer Royal; engraving after a portrait of 1712 by Thomas Gibson. Flamsteed worked at Greenwich for 46 years.

by a few shillings over £20. Flamsteed occupied rooms in the Queen's House (from which he also did some observing) to monitor the Observatory's construction and in July 1676 he moved in.

From then until his death in 1719 he worked there, in nightly dark isolation, 'rectifieing the Tables of the motions of the Heavens, and the places of the fixed stars, so as to find out the so much desired Longitude of places for Perfecteing the Art of Navigation'.

August, to the design of Sir Christopher Wren aided by Robert Hooke of the Royal Society, he launched construction of the Royal Observatory at Greenwich (today's Flamsteed House, the earliest part); it was Britain's first purpose-built 'research institution'. To limit costs, some of the materials were salvaged from elsewhere and it reused the old foundations of demolished Greenwich Castle. The budget of £500, raised by selling old royal gunpowder for recycling, was exceeded

Charles II in the robes of the Order of the Garter, about 1670, after Sir Peter Lely.

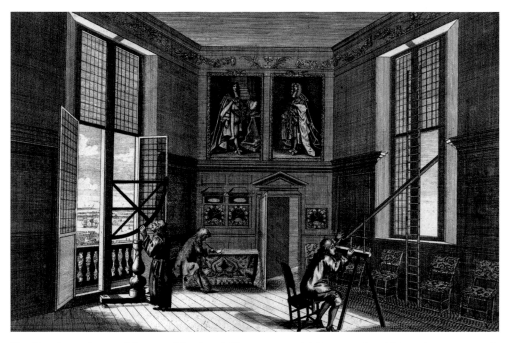

The Star (now Octagon) Room of the Royal Observatory, with Flamsteed and his assistants at work. Portraits of Charles II and James II hang above Thomas Tompion's year-going clocks on the rear wall.

Nine variously distinguished Astronomers Royal succeeded him at Greenwich until its scientific operations moved away from 1946 under the name 'Royal Greenwich Observatory' (RGO), first to Sussex and then Cambridge. The 'longitude problem' was resolved astronomically and through mechanical means (John Harrison's invention of the marine chronometer) during the tenure of the fifth Astronomer Royal, Nevil Maskelyne. 'Greenwich Time', as first made a public standard at the Observatory in 1851 and for the world in 1884, was pioneered by the seventh and first to be knighted, Sir George Biddell Airy.

The fifteenth and current holder of the post since 1995 is Lord Rees of Ludlow, the first to sit in the House of Lords. He has also long survived the RGO itself, since it closed in 1998 in favour of other arrangements. Its original Greenwich buildings first fully opened as part of the NMM in 1967 and today present a working history of over 320 years, with that of the ongoing story of modern astronomy. By doing so they also commemorate Charles II as a king who was more than just a 'merry monarch'.

James II
b. 1633, r. 1685–9

Charles II's Portuguese queen, Catherine, had several pregnancies but no surviving children. All her husband's were illegitimate, so at his death in 1685 his brother James, Duke of York, inherited the throne as James II of England and VII of Scotland.

James was brave, boy and man: he narrowly escaped Parliamentary capture at Edge Hill in 1643 and became an experienced soldier and military commander in both French and Spanish service during Civil War exile. After the Restoration in 1660, this converted – as was then quite common – to sea command as his brother's Lord High Admiral. He successfully led fleets in two major battles of the Anglo-Dutch Wars, the first a notable victory off Lowestoft in 1665 and the second at Solebay in 1672, the last time a British prince commanded a fleet in action.

James II, by Nicolas de Largillière, about 1685. Largillière, a court artist of Louis XIV of France, came specially to England to paint this portrait of James and a matching one of his second wife, Mary of Modena.

At the latter he was well described, in his flagship the *Prince*, by its second captain John Narborough, after the first and other royal staff standing around him were cut down by gunfire:

I do absolutely believe that no prince upon the whole earth can compare with His Royal Highness in gallant resolution in fighting his enemy, and with so great conduct in navigation as never any general understood before him. He is better acquainted in these seas than many masters which are now in his fleet; he is general, soldier, pilot, master, seaman; to say all, he is everything that man can be, and most pleasant when the great shot are thundering about his ears.

Regrettably, James's political judgement was not so good. His first wife Anne Hyde, daughter of the Earl of Clarendon, died in 1671 leaving two surviving daughters, Mary and Anne – both future queens. By then James was a Catholic convert, originally in secret, but in 1673 had to relinquish his post of Lord

High Admiral when that year's Test Act excluded Catholics from public office.

Having weathered later anti-Catholic attempts to exclude him from becoming king, James started his reign with considerable support but immediately faced rebellions in Scotland (led by the Duke of Argyll) and south-west England, headed by the Duke of Monmouth, Charles II's eldest illegitimate son. Both were defeated, Argyll and Monmouth executed, and others ruthlessly pursued – notably in the 'Bloody Assize' led by Judge Jeffreys in western England.

James's subsequent unpopular moves to roll back anti-Catholic legislation and pack public offices with his supporters in that faith caused deepening alarm, and not just for sectarian political reasons. His resistance to advice, including from Parliament, was seen as evidence that he had inherited the same conviction in his divine right as king to direct affairs that had characterised his executed father.

Charles II had earlier spoken of 'la sottise de mon frère' (the folly of my brother) and feared that, if he became king, it would end in early deposition and exile: he proved right. James's fall was triggered in 1687 when his Catholic second wife, Queen Mary of Modena, gave birth to their son James Edward, later called the 'Old Pretender'. This relegated the Protestant heir apparent, James's elder daughter Mary, Princess of Orange, into second place and raised the probability of ongoing Catholic succession through James Edward in due course.

The outcome was the so-called Glorious Revolution of 1688, after a high-ranking 'cabal' persuaded Prince William

'The Battle of Solebay, 28 May 1672', by Willem van de Velde the Elder. The future James II was in overall command in this drawn sea battle of the Third Anglo-Dutch War.

of Orange to mount the amphibious operation which landed a Dutch invasion force at Torbay in November that year. It was generally welcomed and marched on London against only a few Jacobite musket shots of resistance.

James fled and, although captured, was then allowed to escape into exile. His attempts to regain the throne with French backing ended in 1692 and he died near Paris in 1701. The nagging Jacobite threat only faded in 1746, after his grandson Prince Charles Edward Stuart, the Young Pretender ('Bonnie Prince Charlie'), fled from Scotland following defeat at the Battle of Culloden.

James II's links with Greenwich appear slight, in the mentions of him as a yachtsman and in the Palace and Park noted by Pepys and John Evelyn in their diaries. They do contain one of great importance, however, also recorded in a letter by Pepys: writing in November 1694 to Evelyn about Queen Mary II's plan to turn the Palace site into a hospital for seamen, Pepys said that the original idea was, in fact, her deposed father's.

In the 1680s, Charles II had already founded the Royal Hospital at Chelsea for army veterans, although first admissions there were only in 1692. It was logical for James – as able 'pilot, master, seaman' and fighting Lord Admiral – to suggest a similar institution for Royal Naval seamen.

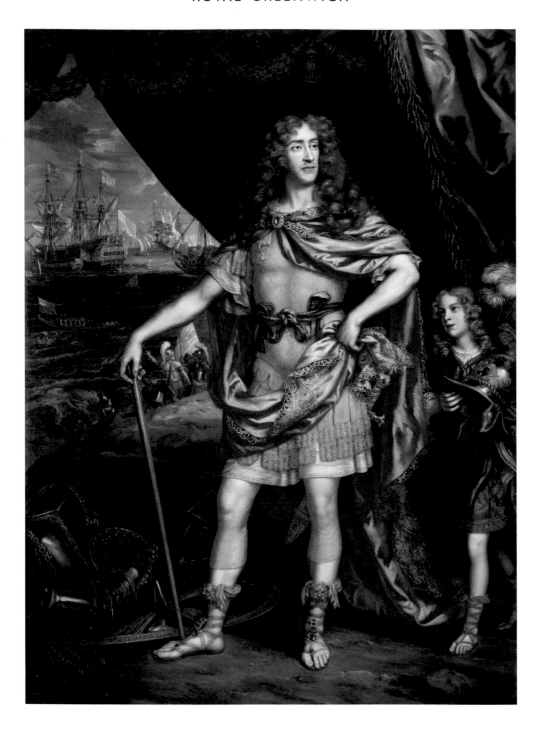

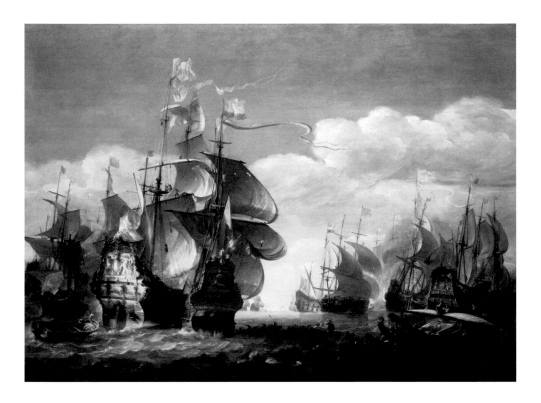

'The Battle of Lowestoft, 3 June 1665', by Hendrik van Minderhout. *The first action of the Second Anglo-Dutch war was a crushing British victory. James's flagship* Royal Charles *is on the left, engaging the* Eendracht, *which later blew up.*

James, Duke of York, 1633–1701, by Henri Gascar. *The portrait shows James II in Roman costume representing Mars, the God of War.*

A commission set up to assess Carisbrooke Castle (Isle of Wight) and Greenwich as potential sites already favoured the latter by the time Queen Mary became its champion, also in 1692. The enduring architectural outcome is self-evident in the former Greenwich Hospital buildings (now the Old Royal Naval College). These and the Hospital's continuing work today as a major Royal Naval charity, are both reasons for giving some credit to the otherwise little-regretted King James.

A Hall of Monarchs

The Painted Hall of Greenwich Hospital is a unique 'royal' interior in spectacular late-baroque style. James Thornhill designed its decoration in stages from 1707 and (with assistants) painted it over the next 19 years to 1726. He completed the main or lower hall ceiling in 1712 and began work on the upper hall in 1718: the entrance vestibule was done last. Thornhill considered himself ill-paid for it at £3 a square yard for the ceilings and £1 for the walls, but it made his reputation and in 1720 he was also the first British-born artist to be knighted.

The Hospital originally intended the Hall to commemorate its founders, William III and Mary II, but this extended to mark its royal patronage through two more reigns – those of Queen Anne and George I. It also looks forward to the next two, of George II and his eldest son Prince Frederick, 'the king who never was', owing to his early death.

Thornhill's vast scheme, in a visual language no longer widely familiar, is striking in two other ways. The first is its artistic irony: 'baroque' originated as an Italian style, often used to glorify kings as representing the virtue and authority of Heaven and justifying their divine right to rule within a generally Roman Catholic framework. The Painted Hall stands this on its head, hailing the triumph of Protestant liberty under William and Mary over Catholic tyranny, as represented by a fallen papal crown and the ill-disguised figure of Louis XIV of France beneath William's feet.

The second unusual feature is that it is the only such pantheon of British monarchs (and so many) that is not part of a palace they built for their own use and glorification, with very limited access. It is the centrepiece of a complex intended for the 'state-welfare' care of their loyal subjects, publicly commemorating the charitable benevolence of its royal patrons.

Greenwich Hospital from the west side, by James Holland, 1850. The Painted Hall, in the King William Court, is on the right.

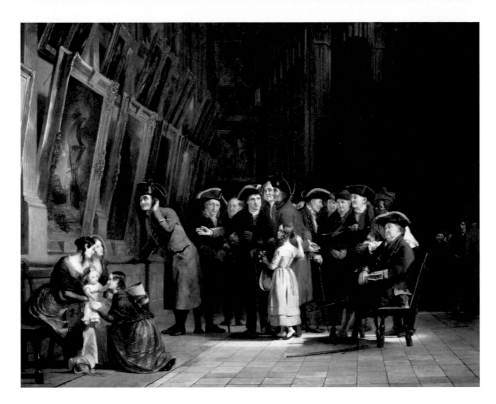

'The United Service', by Andrew Morton (1845). Army pensioners from Chelsea Hospital visit Greenwich Pensioners, in the Painted Hall when it was the Naval Gallery of Greenwich Hospital.

Visitors have always been admitted to the site, the Hall and Chapel, and the main change in its use has been that naval advanced education first replaced seamen's welfare in 1873, until that gave way to it becoming a general university campus from 1998. The American writer Nathaniel Hawthorne summed it up well in 1863, when he wrote:

> *Greenwich affords one of the instances in which the monarch's property is actually the people's … for a nobleman makes a paradise only for himself and fills it with his own pomp and pride; whereas the people are sooner or later the legitimate inheritors of whatever beauty kings and queens create.*

The Painted Hall, following completion of its restoration in 2019.
The lower hall measures 108 x 51 feet and is 44 feet high.

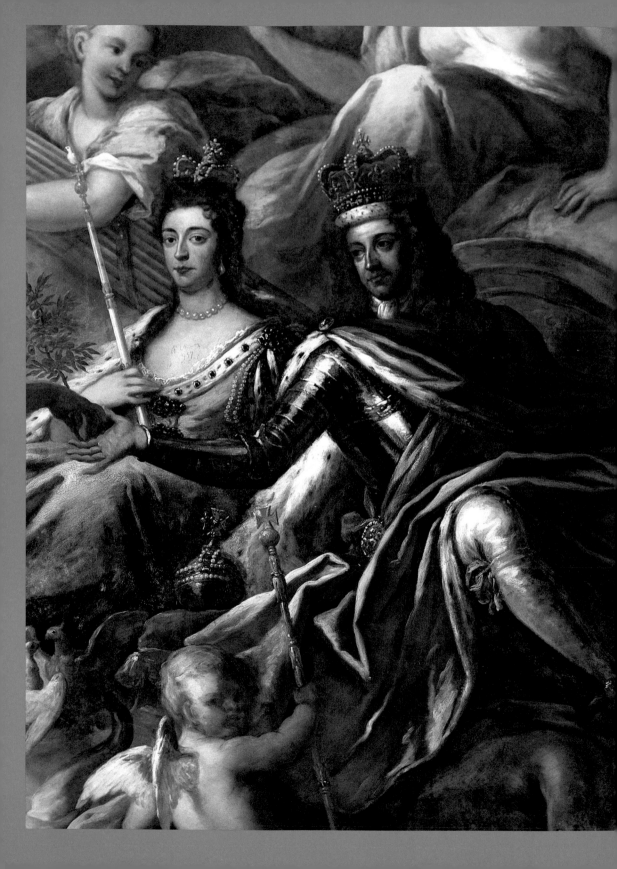

William III b. 1650, r. 1689–1702, and Mary II, b. 1662, r. 1689–94

William of Orange, hereditary prince of the Netherlands, landed with a large invading force at Torbay, Devon, on 5 November 1688 – anniversary of the Catholic Gunpowder Plot against James I in 1605. The west of England welcomed him, following harsh treatment for rebellion against his father-in-law James II, and only a skirmish at Reading with a few of James's Irish troops impeded his popular advance to London.

William's main reason for agreeing to take the British throne was to strengthen defence of the Netherlands against Louis XIV of France. While Dutch through his father and upbringing, he was also half Stuart, since his mother was Princess Mary, the eldest daughter of King Charles I and Queen Henrietta Maria. This made him second cousin to his own wife, Mary, James II's Protestant elder daughter,

and when jointly crowned in 1689 they became Britain's only double-monarchy. William took precedence when in England; Mary reigned in her own right when he was in the Netherlands (mainly resisting King Louis).

In 1692, following huge naval casualties at the Battle of Barfleur, where an allied Anglo-Dutch fleet defeated the French and ended James's attempts to regain his throne, Mary pressed the Treasury to approve the scheme already before it to found a Royal Hospital for Seamen on the former palace site at Greenwich.

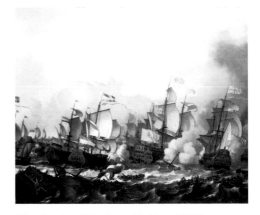

'The Battle of Barfleur, 19 May 1692', by Ludolf Backhuysen. This was the Anglo-Dutch victory which ended James II's attempts to regain his throne.

James Thornhill's portraits of William and Mary in the centre of main ceiling of the Painted Hall. William is receiving an olive branch from a figure representing Peace.

'Prince William of Orange landing at Torbay, 5 November 1688', by Jan Wyck. The white horse is included as a harbinger of kingship: William (crowned in 1689) usually rode a roan.

Advancing this idea, first suggested by her deposed father, became 'the darling object' of her brief reign, as Nicholas Hawksmoor later recalled it. He was already assistant to Christopher Wren, the royal Surveyor, who refused payment 'for so great an object' and first drew up plans that would have re-blocked the view from the Queen's House to the river, as the Tudor palace had done. What exists today arose from Mary's order for a design that preserved the House's 'visto' to the Thames and – for economy – also incorporated the 1660s wing of her uncle Charles II's unfinished new palace (which forms the east front of the Hospital's King Charles Court).

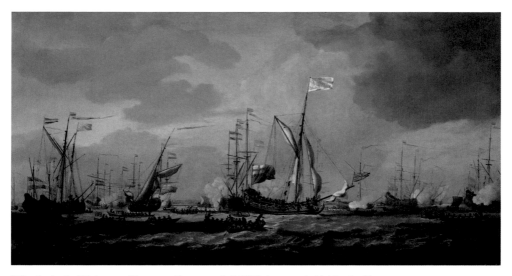

'The Arrival of Princess Mary at Gravesend, 1689', by van de Velde the Younger.
The yacht Mary *bringing the new queen from Holland.*

Mary did not live to see any more built. When she died of smallpox aged 32 in December 1694, William backdated the Hospital's founding charter to 25 October to include both their names and continued the project in her memory, though very slowly. Foundations were only laid in 1696 and he died in 1702, after a fall from his horse, three years before the first 46 Greenwich Pensioners arrived in residence. It was another seven before Thornhill's scaffolding in the Painted Hall (in the King William Court) came down to reveal both of them enthroned in the centre of the main ceiling: as shown there, Mary sits slightly above him, as direct heir to the throne by birth rather than marriage.

It is also a final irony that the royal couple who created the most monumental architectural landmark in Greenwich were the first in over 200 years not to spend time there. Had Mary lived, she might have visited early work on the Hospital; if William did so, there is no obvious mention of it. As an asthmatic he had good reason to avoid the chilly river fogs of Greenwich, which is partly why they gave the site to the Hospital: their favoured homes were in clearer country air, up-river at Kensington and Hampton Court Palace.

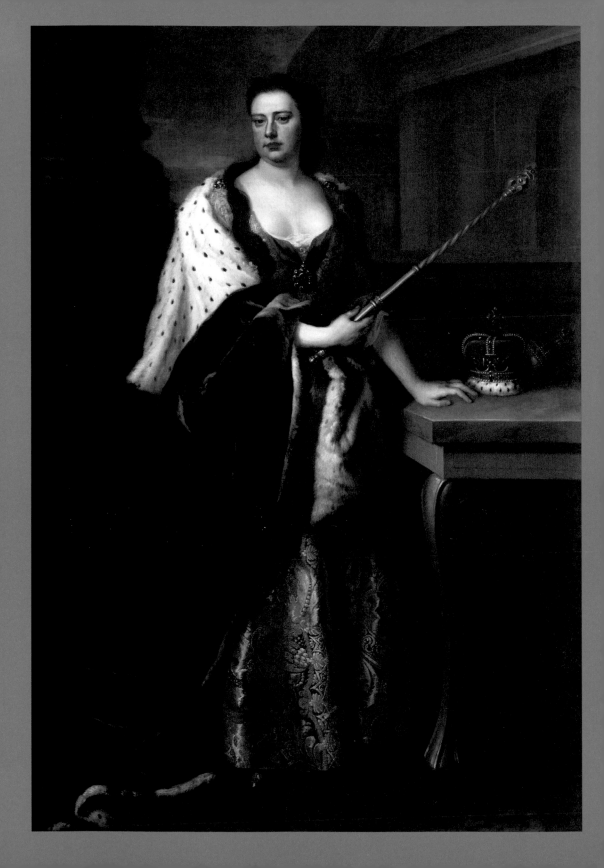

Anne
b. 1655, r. 1702–14

Mary and William had no children and on his death her younger sister Anne inherited the throne. She too died childless, her many pregnancies all ending in stillbirths and early deaths (the oldest at 11) as well as contributing to her poor later health.

Her clever uncle Charles II said of her husband, Prince George of Denmark (m. 1683), that he had 'tried him', drunk and sober, and found 'nothing in him', but he was devoted to Anne, had military experience and served dutifully as her Lord High Admiral until his death in 1708. He was also original chairman of the Grand Committee for building Greenwich Hospital, though it was a largely honorific role, and the key early figures in its progress were Wren as royal Surveyor, the banker Sir Stephen Fox, and John Evelyn as its indefatigable Treasurer to 1703 (when he was 83).

Anne's main contribution, in 1706, was to give it £6,472, representing the confiscated wealth of the executed pirate Captain Kydd.

Queen Anne (1665–1714) in coronation robes; studio of Michael Dahl. Purchased in 1875 for the Naval Gallery from St Alfege Church, Greenwich.

George, Prince of Denmark and Duke of Cumberland (1653–1708), by Sir Godfrey Kneller, c.1704. Queen Anne's husband, shown in ducal robes as Lord High Admiral.

Another of her and Prince George's legacies now at Greenwich is a fine series of portraits of the leading admirals of their time, painted by Sir Godfrey Kneller and Michael Dahl. In effect, they are a series continuing the more famous set of 'Flagmen' painted by Sir Peter Lely for James II, when Duke of York, recording his senior commanders at the Battle of Lowestoft in 1665. Both were given to Greenwich Hospital by George IV in 1824 from the Royal Collection. A number from both sets are usually displayed today in the Queen's House but the portrait of George in Garter robes (by Dahl) – the focal one of the later group – is still in the Admiral's House of the Naval College, where it has hung since at least early in the twentieth century.

A portrait of Anne by Dahl's studio is also in the Greenwich Hospital Collection at the NMM. This was painted to hang in St Alfege, the magnificent Greenwich parish church built by Nicholas Hawksmoor after the roof of its medieval predecessor collapsed in 1710. St Alfege was consecrated in 1718 as the first of Anne's 'fifty new London churches' scheme, though only 12 were built. In the 1870s the parish disposed of paintings in it and in 1875 the Admiralty authorised Greenwich Hospital to pay £10 for Anne's full-length portrait to join that of her husband, then in the Painted Hall. Though these are again separated, she and Prince George are not: both still look down from a double portrait in the centre of Thornhill's upper hall ceiling, surrounded by figure groups representing the four then-known continents; Europe, Asia, Africa and America.

Had Anne lived a little longer the Queen's House would probably also have come into early full control of Greenwich Hospital, which had long cast envious eyes on it. From 1708 it was the 'grace-and-favour' residence of the Ranger of Greenwich Park and, by doubling in that role from 1710 to 1743, early Governors of the Hospital lived there.

By 1714, Anne was nearly ready to give it to the Hospital but died on 1 August before doing so. She had already taken the last substantial element of its original decoration in 1708, when Orazio Gentileschi's nine ceiling paintings in its Great Hall were removed and later presented to her favourite, Sarah Churchill, Duchess of Marlborough. Since 1711, in rather mutilated form, they have decorated the hall ceiling of her London residence, Marlborough House, today the headquarters of the Commonwealth.

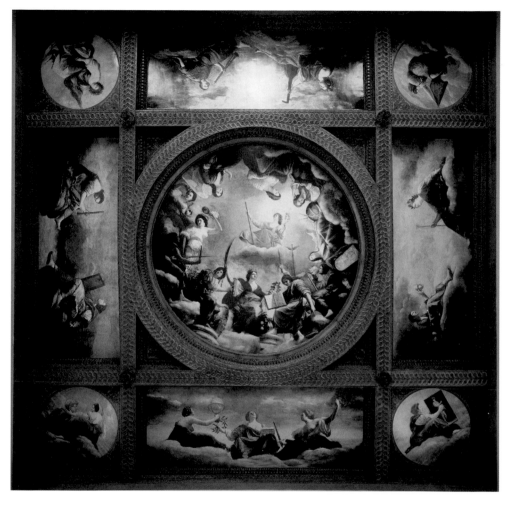

A digitally generated copy of Orazio Gentileschi's Hall ceiling, in the Queen's House in the 1990s. Queen Anne gave the original paintings to the Duchess of Marlborough.

Queen Anne also just lived long enough to give royal assent to the Longitude Act of July 1714, which provided for awards of up to £20,000 (£3.17 million in 2020 terms) for accurate methods of calculating longitude at sea. The Astronomers Royal at Greenwich were all closely involved in this matter until solutions were approved in the 1760s, including Harrison's 'H4' marine timekeeper of 1759, and in related work that continued into the nineteenth century.

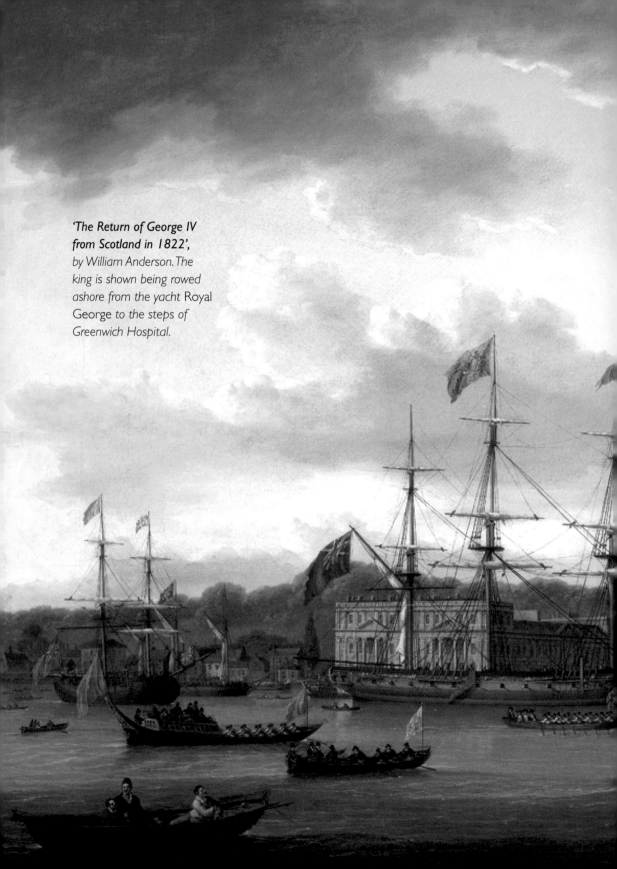

'The Return of George IV from Scotland in 1822', by William Anderson. The king is shown being rowed ashore from the yacht Royal George to the steps of Greenwich Hospital.

HOUSE OF
HANOVER

George I
b. 1660, r. 1714–27

In Britain, the Stuart dynasty ended with Queen Anne. In 1707, the Act of Union joined Scotland with England under a single Parliament in London, bringing 'rule' into line with the joint Stuart 'reign' that began in 1603 when James VI of Scotland also became James I of England.

The end of the immediate Protestant Stuart line inevitably revived Catholic hopes of reinstating the Jacobite branch of the family, however. The exiled James II's son – James Edward Stuart, 'the Old Pretender' – was still only 26 and already recognised by France and Spain as the legitimate 'James III and VIII'. As a Catholic he was excluded from the British throne, as were the next 55 others in order of birth for the same reason. The 57th was George, Prince-Elector of Hanover, Protestant great-grandson of James I, through his daughter Elizabeth, 'Winter Queen' of Bohemia.

George was a multi-lingual German (but with little English), then aged 54, and already had just one 30-year-old son, also George, one daughter, and lived with his long-term German mistress.

George I (1660–1727) by Sir Godfrey Kneller. Inscribed on the back 'A present from ye Royal Family' it is thought to have been a gift to the father of Admiral Edward Vernon, 1684–1757.

George II as Prince of Wales, *with Admiral Sir John Jennings and James Thornhill. A sketch by Thornhill for the west wall of the Painted Hall.*

In 1694 he had divorced his neglected wife and confined her under lifelong house arrest for taking a Swedish lover: he may also have abetted the latter's murder.

He arrived in England on the night of 18 September 1714, landing at Greenwich Hospital and spending the night in the Queen's House. His landing is shown in grandiose, romanized style on the north side of the upper Painted Hall, facing the similar representation of William III's landing at Torbay in 1688.

Between them on the great 'West Front' he sits crowned, in the centre of a towering composition of emblematic figures, many also being portraits of his immediate family (except his wife), from his mother and sisters down to his numerous infant grandchildren. Above a background including a pyramid (symbolizing stability), an overflowing cornucopia of plenty, and the dome of St Paul's Cathedral, is the legend *Nova Progenies in Coelo* – 'a new race in Heaven' – that of the House of Hanover.

George was crowned in October 1714 and proved a diligent and careful ruler in turbulent times. In 1715, the 'Old Pretender' James Stuart landed in Scotland to head a Jacobite rebellion, but fled the following year when it was rapidly crushed. A similar northern uprising failed even faster in 1719. Both led to the confiscation of rebel estates that George used wisely, including for improvements in the north, though Greenwich Hospital was also a later beneficiary under George II.

The most seismic economic event of his reign was the notorious collapse of the South Sea Company in 1719–20, known as the 'South Sea Bubble'. This arose from an attempt to reduce the cost of the national debt by encouraging speculation in South American trade, itself unrealistic given ongoing war at the time with Spain and Portugal, and their jealous colonial monopoly there. The most significant

Medal commemorating the arrival of King George I in England and dominion of the seas, by John Croker, 1683–1760.

106

'The 'Peregrine' and other Royal Yachts off Greenwich', by Jan Griffier, c.1710–15. *The ship-rigged Peregrine* (centre) *was the yacht that brought George I to England in 1714.*

politician of George's reign, Sir Robert Walpole, skilfully resolved the crisis and became, in effect and in the modern sense, Britain's first 'Prime Minister' until after the king's death.

George spent about a fifth of his reign on six extended visits to Hanover, which was where his heart and many justifiable concerns lay: the first was in 1716 and the last began in 1725. Departures and arrivals were frequently from and to Greenwich Hospital by royal yacht – often a number of them for family, courtiers, servants and baggage –

since Deptford Dockyard, just upstream, had long specialised in building and maintaining the yachts for official uses from London.

With Walpole's influence, and the king's temporary replacement by a Regency Council during his later absences, Parliamentary government strengthened in the 1720s. George himself still lies in Hanover, since he died on 11 June 1727 at Osnabrück, two days after suffering a stroke during his final German visit. He was the last British king buried abroad.

George II b. 1683, r. 1727–60, and **Frederick, Prince of Wales**, 1707–51

George II is represented at Greenwich on the west wall of the Painted Hall as a young man in armour in about 1718; his eldest son Frederick, later Prince of Wales, stands beside him. Frederick was then about 11 and not even in England, since his parents left him in Hanover when they came over in 1714 and he was only allowed to follow in 1728, just after his father became king.

This long separation formed a permanent rift between them, not least because his parents were more devoted to their younger children. Thus estranged, the prince favoured political opponents of his father and was dissipated and difficult, but also musical and a notable patron of the arts: Thomas Arne's 'Rule Britannia' first appeared in *Arthur*, a masque written for him in 1740, and he commissioned William Kent, master of the mid-century Rococo style, to design what is still called Prince Frederick's Barge (1732) for his use on the Thames.

George II had little interest in the arts or reading, and in 1757 gave the royal library to the recently founded British Museum. He instead enjoyed hunting, cards and shared the characteristic Hanoverian interest in military matters. In the War of the Austrian Succession (1740–7), he was the last British monarch to lead an army into action, at the Battle of Dettingen in 1743.

*George II, shown in armour as Prince of Wales, with his son **Prince Frederick** (1707–51, dressed in red) on the West Wall of the Painted Hall; both standing, lower right, with George I to their left. Thornhill is on the right below them.*

Prince Frederick's barge, 1732, last used in 1849. It came to Greenwich in 1951.

George II (1683–1760), shown on a medal commemorating naval action against the French and Spanish off Toulon in 1744, by Adam Werner of Augsburg.

This occurred while Commodore George Anson was making his celebrated voyage round the world (1741–4), primarily to attack enemy Spanish interests in the Pacific, from which his ship *Centurion* returned with a vast treasure in captured silver. Though it can no longer be seen, the track of this voyage was originally carved on the five-ton terrestrial globe that, with a matching celestial one, tops one of the West Gate pillars of the Old Royal Naval College. The gate was erected in 1751 (originally on the old Hospital boundary about 100 yards further east than today), the year in which Anson

became First Lord of the Admiralty and remained so for most of the time to his death in 1762.

Despite the king's lack of specific naval interest, his reign had other important effects at Greenwich. In 1735 he gave Greenwich Hospital the huge northern estates of James Radcliffe, Earl of Derwentwater, who had been executed as a Jacobite rebel in 1716. Their income funded the building of the Hospital's final (Queen Mary) court, thereby completing Wren's great complex in 1751.

George II's statue (1735) in the Grand Square. Since this early photograph was taken, about 1845, atmospheric pollution has dissolved even more of the detail of Rysbrack's marble statue.

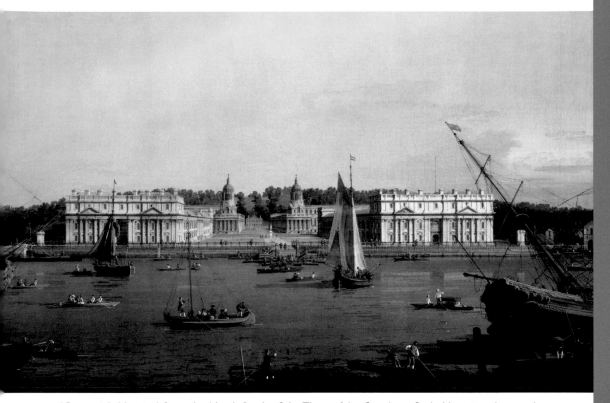

'Greenwich Hospital from the North Bank of the Thames', by Canaletto. Probably painted to mark the Hospital's completion in 1751, over six reigns from Charles II to George II.

In 1735, too, King George himself was commemorated by his now much-eroded statue in the Hospital's Grand Square. Wishing to have a statue of William III, its directors had bought the marble block after its capture from the French at sea some thirty years before, but it remained unused until the longest-serving Hospital Governor (1720–43), Admiral Sir John Jennings, paid John Michael Rysbrack £400 to carve one of George instead.

Jennings was also the last Governor to live in the Queen's House and double-up as Ranger of Greenwich Park. It was during his time, in April 1736, that the House was used to receive Princess Augusta of Saxe-Gotha on her arrival in England to marry Prince Frederick. When he first came to meet and dine with her there, he was reported to have returned to London that evening in his barge. Their marriage produced eight children,

of whom the last, Princess Caroline, was born after Frederick's early death in 1751, long before his father.

Five years later, in 1756, the Seven Years War with France began, soon bringing in allies on both sides. A notorious early British disaster in 1757 was the loss of Minorca, a significant Royal Naval base, after Vice-Admiral John Byng

Major-General James Wolfe (1727–59). His bronze statue in Greenwich Park was a gift from the Canadian people in 1930. It is by the Canadian doctor and sculptor Robert Tait McKenzie (1867–1938).

was unable to dislodge a French invasion force. Byng came home under arrest and was ignominiously confined in attic rooms at Greenwich Hospital before facing a court-martial at Portsmouth, which condemned him to death for failure to 'do his utmost' in the face of the enemy.

The death sentence was mandatory but the court recognised contributing factors for which Government bore greater responsibility, and recommended mercy. But with public opinion seeking a scapegoat the elderly king was ruthless in refusing a pardon. Byng – who faced it all with calm courage – was shot on the quarter-deck of his own flagship at Portsmouth. 'In this country [England]' as Voltaire cuttingly wrote, 'it is thought good to shoot an admiral from time to time to encourage the others.'

The Seven Years War has been called the first 'world war', with land campaigns in Europe, North America and India. The sea became the highway for moving armies and supplies around more of the globe than ever before during a single war. It also continued to be one for mercantile trade needing constant defence against enemy attack, and was itself a field of naval battle.

By 1759, the effect of Anson's reforms at the Admiralty helped to make this

'the year of victories', still celebrated by the song 'Heart of Oak' that the great actor, David Garrick, wrote to mark it at Christmas. Major naval actions were victories over French fleets at the Battle of Lagos (Portugal) and Hawke's even more spectacular one in rapidly falling night among the shoals of Quiberon Bay (southern Brittany) on 20 November.

By an extraordinary coincidence, he was winning it at the exact time the body of 32-year-old Major-General James Wolfe, who had died capturing the city of Quebec from the French in September, was being buried in St Alfege Church, Greenwich. Quebec was undoubtedly the most significant victory of the war, achieved after two summers of campaigning by a joint army and navy force sent out each year from Britain. It required the charting of much of the St Lawrence River – the city is over 300 miles from open sea – a task in which the young James Cook gained early notice. Although further local fighting was involved, the taking of Quebec secured Canada as a British possession, much as Robert Clive's victory over the French at Plassey in India two years earlier proved the key to establishing British colonial dominance there.

Both, with the other successes of 1759, ensured that George II died in

George II in 1759, by or after Robert Edge Pine.

some reflected glory the following year. While Wolfe was buried at Greenwich because his family lived there (the house still stands on the west side of the Park), Clive also had a later local connection by marriage. In 1753, well before Plassey and his fame as 'Clive of India', he married Margaret, sister of Nevile Maskelyne, who from 1765 to 1811 became fifth Astronomer Royal at the Observatory, under the next reign. Margaret Clive herself spent a number of years living nearby at Westcombe, while her husband was in India.

113

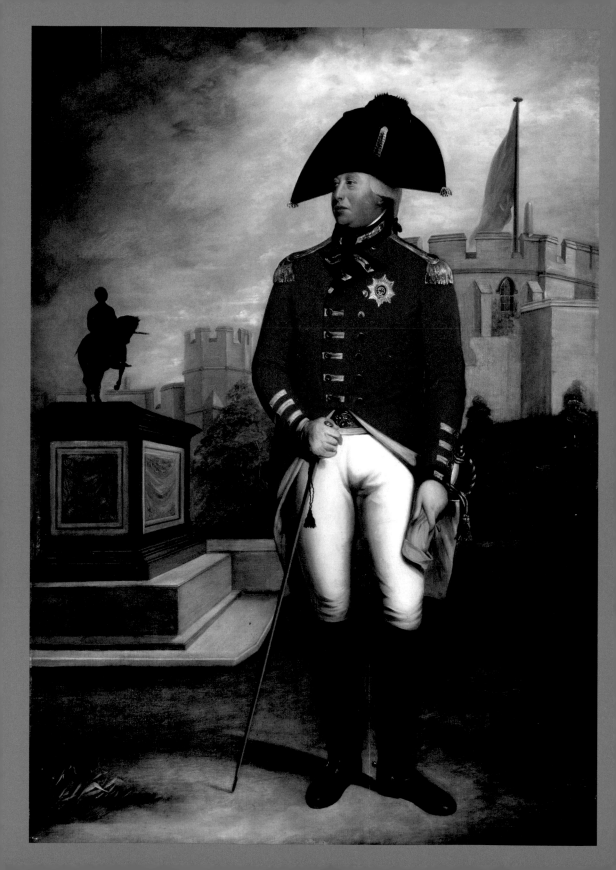

George III
b. 1738, r. 1760–1820

George III, second child and eldest son of Prince Frederick, inherited his grandfather's throne in October 1760. He was then 22 and one of Admiral Lord Anson's last sea-going duties was to command the squadron that, in dreadful weather, escorted his bride, Princess Charlotte of Mecklenburg-Strelitz, from Stade (Germany) to Harwich in August 1761.

Their marriage proved long, successful and even more prolific than his father's and grandfather's. There were 15 children, from the future George IV in 1762 to Princess Amelia in 1783, of whom eight were sons and the only early deaths were the last of these, Princes Octavius and Alfred (at four and two). All the others except Princess Amelia (27) and Prince Edward, Duke of Kent (53) – father of Queen Victoria – lived into their 60s or longer.

Other Hanoverian characteristics carried forward were the poor relationships

George III (1738–1820). *A small (studio) version of a portrait by Sir William Beechey, painted about 1800. The king is in general's uniform with Windsor Castle behind.*

between the king and his sons, and army rather than naval interests. George III, however, was the first Hanoverian who spoke English as his native language and a man of energetic if increasingly eccentric character: he was deeply conservative, moral, devoted to the family that his controlling manner and short temper often antagonized, and hard-working in his duties. He also enjoyed the arts and music, and had serious scientific pursuits. His interest in botany and agricultural improvement earned him the nickname of 'Farmer George', while other enthusiasms were astronomy and mechanics, including timekeeping.

It was he who, in the end, insisted that John Harrison receive the full recompense provided for under the Longitude Act of 1714 for invention of the marine chronometer – of which the four main original models are all now at Greenwich. He was also a keen supporter of voyages of exploration, not least for their botanical potential, especially when Joseph Banks became his principal natural-science advisor after accompanying Cook's first Pacific

voyage in the *Endeavour* (1768–71).

Thereafter, four places became an early national base of wide scientific inquiry, international correspondence and exchange: Banks's house in Soho Square; the Royal Society (of which Banks became President from 1778 to his death in 1820); the Royal Botanic Gardens and the King's Observatory, both at Kew; and the Royal Observatory at Greenwich, mainly under Maskelyne's long direction (1765–1811). The web spun between them and elsewhere had Banks at its centre, influential both in his own expertise but also because he had the ear of the king.

Their joint enthusiasm to transplant breadfruit from Tahiti to the West Indies, and bring back many other exotic plant species to Kew, was eventually achieved by William Bligh's second Pacific voyage in the *Providence* and *Assistant* (1791–3).

Bligh's first attempt in the *Bounty* failed, substantially because he had to accept arrangements in which he had little part and which an unenthusiastic Admiralty had already agreed owing to Banks's influence with the king. These included selection of a ship he would not have chosen but which Banks did, on its suitability for plants, and an inadequate command structure for a long voyage.

While the botanical legacy of the expeditions of Cook, Bligh and others under George III is today found in the archives at Kew and the Natural History Museum, much of the related artistic record, the instrumentation and other 'maritime relics' from them are now at Greenwich. Cook himself was briefly a resident Captain of Greenwich Hospital before his final voyage, and the portrait

Model of the 100-gun Royal George, *made for presentation to George III and given to the Naval Gallery at Greenwich by William IV. The ship was launched at Woolwich in 1756.*

Model of the 74-gun Bellona *of 1760; this was either made or adapted to demonstrate copper-bottoming.*

of him that Banks commissioned in 1776 to hang at Soho Square came to the former Naval Gallery in the Painted Hall in 1824. Cook's widow, who outlived him by 55 years, is known to have seen it there sometime before her death in 1835.

In the same way that Banks engaged George III's botanical sympathies in the cause of scientific exploration, John Montagu, 4th Earl of Sandwich, played on his interest in technology for the benefit of the Navy. Sandwich was not a seaman but a political administrator; intelligent, hard-working and only modestly wealthy. He served three terms as First Lord of the Admiralty – the last during the American War of Independence (1776–83).

The naval aspect of the war required great improvements in the efficiency of the Royal Dockyards and the quality of the ships they built, to endure distant foreign service where repair facilities were limited. Sandwich arranged for the king to tour the royal yards and inspect their work, and had ship models – and even paintings of ship models – made for him to engage his curiosity about how things worked.

One of the finest such models is that of the 100-gun *Royal George*, in which the internal cabin doors are inlaid with mother-of-pearl (probably to simulate painted marbling) even though they could barely be seen. William IV later presented the model to Greenwich Hospital, though the ship was less lucky: it sank at anchor off Portsmouth in 1782, through sudden accident, with the loss of over 800 lives.

Another model, of the 74-gun *Bellona*, is the first to demonstrate the technique

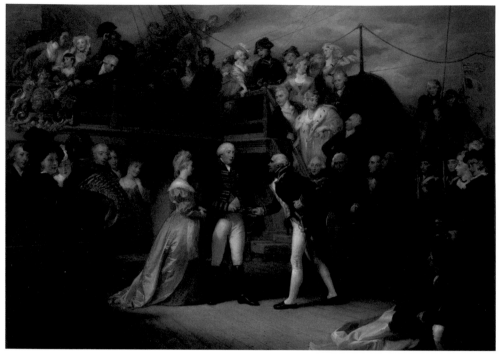

'Visit of George III and Queen Charlotte to Howe's flagship, 'Queen Charlotte', 26 June 1794', after the Battle of 1 June. The king is presenting Howe with a jewelled sword.

of copper-bottoming, which began during the American war, to protect wooden warships against shipworm, improve their sailing qualities and keep them longer at sea between dock repair, which could also only be done in England. The cost was huge and the *Bellona* model is thought to have been made to take to the king, explain the process and help gain his approval. When he gave it, the entire fleet was first coppered within three years.

Naval reforms paid off when Britain joined the French Revolutionary War early in 1793 and saw Lord Howe defeat a French fleet 300 miles off Ushant on the 'Glorious First of June' 1794. It was the first time since 1665 that the opening naval battle of a war was a British victory rather than a draw or, in effect, a strategic defeat (as with Byng at Minorca) thanks to technical, manning or command failings.

The reason Howe's great victory is now little recalled is because of the precedent it set for the five that followed; from Cape St Vincent and Camperdown

in 1797, against the Spanish and Dutch respectively, to that against France and Spain at Trafalgar in 1805. Of these, Cape St Vincent first brought Horatio Nelson to public fame, and the last three – the Nile (1798), Copenhagen (1801) and Trafalgar – ensured his 'immortal memory'.

While George III valued Nelson's success and loaded him with honours for it, including a viscountcy, he disapproved of his occasional insubordination and his irregular private life. His mistress, Lady Hamilton, was never admitted to court and when Nelson attended, the king usually paid him minimal attention. George's most perceptive comment on the greatest admiral of his age was prompted by news of his death at Trafalgar: 'He died the death he wished.'

No one would have expected him to attend Nelson's lying in state in the Painted Hall (4–7 January 1806), or his state funeral in St Paul's on the 9th, but the Prince of Wales and two of his brothers, including the future William IV, were at St Paul's. Four years later the king's so far occasional mental illness became permanent and he spent his last years in secure care at Windsor Castle.

Figurehead of the Royal Charlotte, 1824. A carved portrait of the young Queen Charlotte (1744–1818) from the later yacht named after her.

Medal commemorating British victories of 1798; silver-gilt by Conrad Heinrich Küchler. The great naval one was Nelson's victory at the Battle of the Nile on 1 August.

George IV
b. 1762, Prince Regent 1811–20, r. 1820–30

Prince George and his brothers all had difficult relations with their father. The young George was clever, handsome, an able pupil, had immense charm and became the most discerning royal connoisseur of the visual arts since Charles I. But on being given his own establishment and a generous income at the age of 18, he began a life of debt-ridden extravagance and debauchery that destroyed his looks, health and public popularity: he died at Windsor in 1830 – reclusive, immobilised and an obese 20 stone (127 kg).

George at his elegantly glittering best is seen in paintings by the great portraitist of his day, Sir Thomas Lawrence; at his worst in images by the equally great caricaturist, James Gillray. Despite making an illegal early marriage to the older (and Catholic) Maria FitzHerbert, he had a string of other mistresses and in 1795, at his father's insistence, married his cousin Princess Caroline of Brunswick. Although this produced a daughter, Princess Charlotte (d. 1817), the couple were entirely incompatible and separated in 1796.

Despite her own failings, Caroline won much public sympathy and, with his father, became George's regular *bête noire* until her own death in 1821. Her first landing by yacht from Brunswick was at Greenwich Hospital in 1795, when she was met by an honour guard of Pensioners and heard to remark (in French): 'Are all men in England missing an arm or a leg?'

From about 1799 to 1814 she lived at Montagu House in the south-west corner of Greenwich Park. Only part of the rear wall survives, incorporated with the Park's, but a sunken garden plunge-pool built for her, now called Queen Caroline's Bath, is also still visible there. Though appointed Ranger of the Park from 1806, she accepted a financial settlement to remain at Montagu House, rather than moving to the Queen's House, which thereby ceased to be that of the Ranger. It was instead granted by George III as a new home for the Royal Naval Asylum, an orphanage school that moved from Paddington in 1807 and, in 1825, formally became part of the pre-existing Greenwich Hospital School.

George IV (1762–1830); marble bust by Sir Francis Chantrey. This was a gift from the king to F.J. Robinson (later 1st Earl of Ripon), Chancellor of the Exchequer and briefly Prime Minister.

George forbade Caroline's attendance at his coronation in June 1821, and when she tried to assert her right to attend as queen (since they were never divorced) she was turned away from barred doors: the experience perhaps hastened her death that August.

The new reign was preceded, from 1811, by George's nine years as Prince Regent during his father's long seclusion. Both then and as king his greatest impact was as the unquestioned leader in fashion and the arts. St Mary's Lodge in the north-west corner of Greenwich Park is an early building by his favoured architect, John Nash, who later built London's Regent Street, and remodelled Buckingham Palace for him. He also built Brighton

'A Voluptuary under the Horrors of Digestion'.
James Gillray's savage image of George IV's self-indulgent lifestyle when Prince of Wales. The prince was 30 when it was published in 1792.

A VOLUPTUARY under the horrors of Digestion.

Princess Caroline arriving at Greenwich in the royal yacht Augusta *to marry the future George IV, 5 April 1795. Aquatint from the* Naval Chronicle, *1820.*

Pavilion, the ultimate expression of George's early role in making 'the seaside' a place of fashionable resort.

Although it bears George III's name, John Yenn's fine neo-classical west range of the King Charles Court of Greenwich Hospital was built in 1812–15 under the Regency, replacing Wren's decayed original one. In 1822 George IV also made the first visit of a British monarch to Edinburgh since the seventeenth century, sailing from and returning to Greenwich Hospital by royal yacht. Large crowds witnessed both events.

Two years later his greatest local contribution was to support a longstanding Hospital idea to make the largely unused Painted Hall an even greater public attraction than it already was, by converting it into 'The National Gallery of Naval Art'.

Originally proposed in 1795 by Nelson's early captain, Lieutenant-Governor William Locker, this idea was revived by his son Edward, after he became the Hospital Secretary in 1819. The Lockers' intention was partly political and partly charitable. As conservatives in

Caricature of George IV being seasick (or from the unwanted attentions of his estranged wife, Queen Caroline), published by John Fairburn in 1820.

revolutionary times, they aimed to make the artistic celebration of British naval prowess a pantheon of loyal, patriotic example. As demands on the Hospital were also huge, owing to the large numbers of seamen disabled in the French Wars of 1793–1815, this was also an ideal way to keep up its public profile and income in the turbulently depressed post-war period.

The Gallery was created almost entirely by seeking gifts of paintings of distinguished naval officers and their actions, adding to just over thirty which had arrived that way (including bequests) since about 1711. One of the greatest of these is Gainsborough's full-length portrait of Lord Sandwich, commissioned in 1783 by the Governor,

Admiral Sir Hugh Palliser, to mark Sandwich's support to the Hospital (and for appointing Palliser, against popular sentiment).

Edward Locker's great coup was when George IV became principal donor in 1824, presenting the seventeenth- and early eighteenth-century portraits of admirals painted for James II and under Queen Anne, especially Lely's celebrated 'Flagmen' set. With such royal example, others rapidly followed.

Admiral Sir John Harman *(d. 1673).*
The most dashing portrait in Sir Peter Lely's 'Flagmen of Lowestoft' set, which George IV gave to the Naval Gallery at Greenwich in 1824.

When the Naval Gallery opened in the Hall in April 1824 it was Britain's earliest 'national' gallery, with over double the paintings and more rapidly growing than the early 'National Gallery' proper. This opened about three weeks later, originally in Angerstein House, Pall Mall, after the Government bought the collection of the banker John Julius Angerstein – who is buried in St Alfege's, since his country villa (Mycenae House) was also at Greenwich, and still survives.

In 1822 – on the advice of Lawrence as President of the Royal Academy – the king also gave J.M.W. Turner his only royal commission. This was to paint his huge second version of the Battle of Trafalgar, as a pair for P.–J. de Loutherbourg's earlier view of Lord Howe's action of 1 June 1794, which the king had already bought when Prince Regent for his official residence, Carlton House.

In 1824 both were hung as part of redecoration of the state rooms at St James's Palace but Turner's painting proved so controversial that in 1829 the king sent them to the Naval Gallery instead. They were the last of his several further gifts to it and, as its largest-ever additions, at first had to hang high in the entrance vestibule.

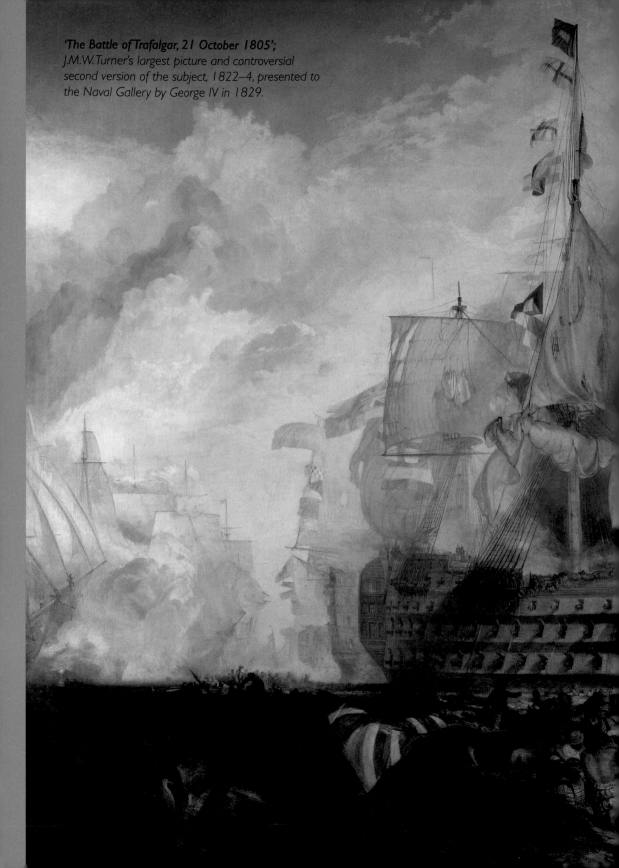

'The Battle of Trafalgar, 21 October 1805';
J.M.W. Turner's largest picture and controversial
second version of the subject, 1822–4, presented to
the Naval Gallery by George IV in 1829.

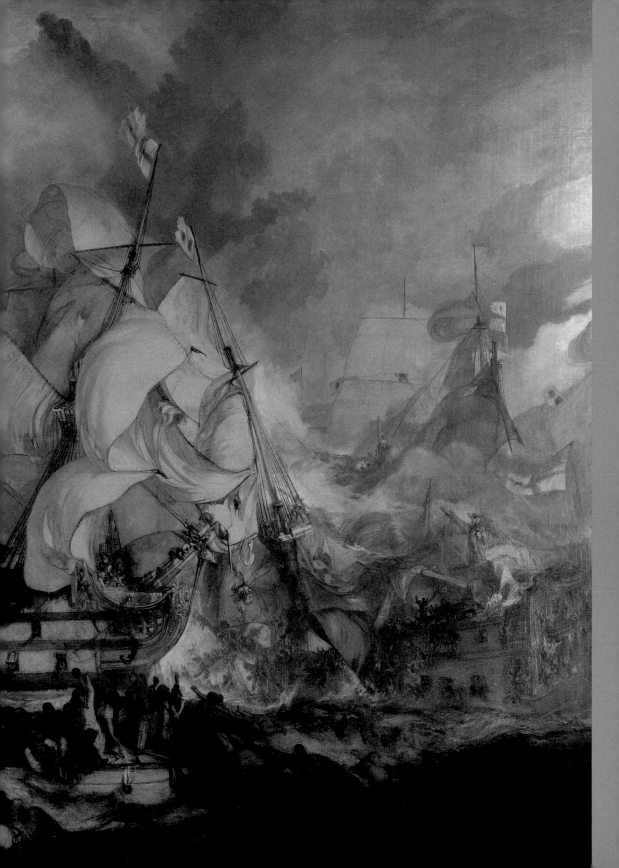

The Naval Gallery in the Painted Hall, Greenwich, in 1865. Now almost forgotten, it was Britain's earliest 'national' historical gallery, 1824–1936.

John Montagu, 4th Earl of Sandwich (1718–92), by Thomas Gainsborough, 1783. Commissioned for Greenwich Hospital by its Governor, Sir Hugh Palliser.

Criticism of the Turner by seamen – including George's brother and successor, William IV – continued at Greenwich and Turner (d. 1851) himself heard a Pensioner abuse it there at least once. As part of a major rearrangement in 1845–6, it nevertheless became a centrepiece of the display, facing the de Loutherbourg across the lower Hall, until the collection as a whole passed into the care of the new National Maritime Museum in 1936. It is still a picture about which nautical and art specialists tend to have diverging views.

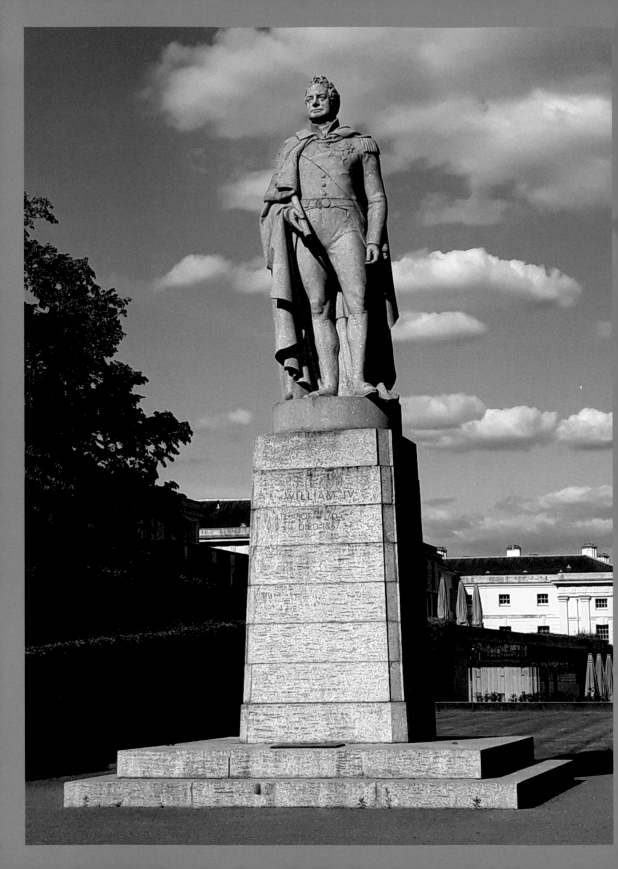

William IV
b. 1765, r. 1830–7

The death of George IV's daughter Charlotte in 1817 and of his eldest brother the Duke of York in 1827 made the second brother next in line to the throne. At 64, Prince William Henry, Duke of Clarence, was the oldest heir apparent so far, reigning as William IV. He was popularly known as 'the Sailor King', since he joined the Navy aged 13 and rose to captain before coming ashore in 1790.

He was, at best, an adequate rather than good officer, who counted himself a great friend of Nelson after serving under him as a captain in the West Indies, and was best man at his wedding there in 1787. This did neither of them much good, however, owing to the indiscretions of both and William's poor relations with his father, George III.

While not as dissipated as George IV, William also lived an irregular life and had illegitimate children by several mistresses: ten, called the Fitzclarences,

William IV (1765–1837). Samuel Nixon's granite statue was erected at the head of London Bridge in 1844 but was moved to Greenwich in 1936.

were from his twenty-year relationship to 1811 with the actress Dorothea Jordan (d. 1816). Eventually, in 1818, a suitable bride was found for him in Princess Adelaide of Saxe-Meiningen: practical and tolerant, she took him and the nine surviving Fitzclarences in hand and it proved a happy marriage, although their own two daughters died young.

In 1820, after William's proximity in the succession clarified, George IV appointed him Lord High Admiral, a solely honorific intention that quickly misfired when he seized on it with long-thwarted professional interest. He at first managed to effect some useful minor reforms, until his brother was obliged to dismiss him in 1823 after he briefly but almost literally vanished to sea again without proper notice or authority.

His most important role as king was to support the great Parliamentary Reform Act of 1832 but his eccentric, 'unkingly' behaviour continued to exasperate courtiers and politicians, although often pleasing his subjects. He was very popular in the Navy, granting it the right to drink the 'loyal toast' while seated,

KING WILL⁰ 4ᵗ & QUEEN ADELAIDE
landing at Greenwich, Aug.ᵗ 5.ᵗ 1830.

Printed & Sold by W.Belch.

258. Borough. London.

'William IV and Queen Adelaide landing at Greenwich, 5 August 1830'. A popular print of the first of William's many visits as king.

from his own head-bruising experience of low 'tween-decks: his introduction of red as an additional colour-trim in naval officers' uniforms (1830–43) was more equivocally received and did not last.

As Lord High Admiral, William had shown active interest in the Greenwich Hospital School and, when he became king, his old shipmate and friend Admiral Sir Richard Keats was already Governor of the Hospital.

William and Queen Adelaide became regular visitors, often by barge, and the king made it a practice to attend Chapel there on any Sunday that was also an anniversary of a great naval victory. After these services he enjoyed talking to the Pensioners, being perfectly on their wavelength in language and past experience, and usually slipped 'tobacco-money' into their hands as well. After Keats died in 1834 the king's visits continued under the Governorship of Vice-Admiral Sir Thomas Hardy, Nelson's former flag captain and friend, and he only approved Hardy's appointment on condition that he be recalled to sea if naval emergency required.

Keats's memorial bust by Sir Francis Chantrey, which William commissioned, still stands in the College chapel (with Hardy's, carved later as a pair by William Behnes) and he also made significant gifts from the royal collection to the Naval Gallery. These included the uniform coat Nelson wore at the Battle of the Nile in 1801 and Henri Gascar's fine portrait of James II when Duke of York (see p.88) – James being the only previous 'Sailor King' through his pre-1673 role as a fighting Lord High Admiral for Charles II.

While George IV had welcomed and enjoyed his Regency, William's dread was that his early death might require one before his niece, Princess Victoria, was able to inherit the crown on reaching the age of 18. He died on 20 June 1837, just under a month after she did so, and from 1842 himself took a central position in the upper hall of the Naval Gallery at Greenwich in the form of a marble bust by Chantrey, presented by Queen Adelaide.

'A True British Tar'. James Gillray's caricature of the future 'Sailor King' as a truculent British naval seaman.

Prince William Henry as a naval midshipman during the American War of Independence; from a print after Benjamin West, 1782.

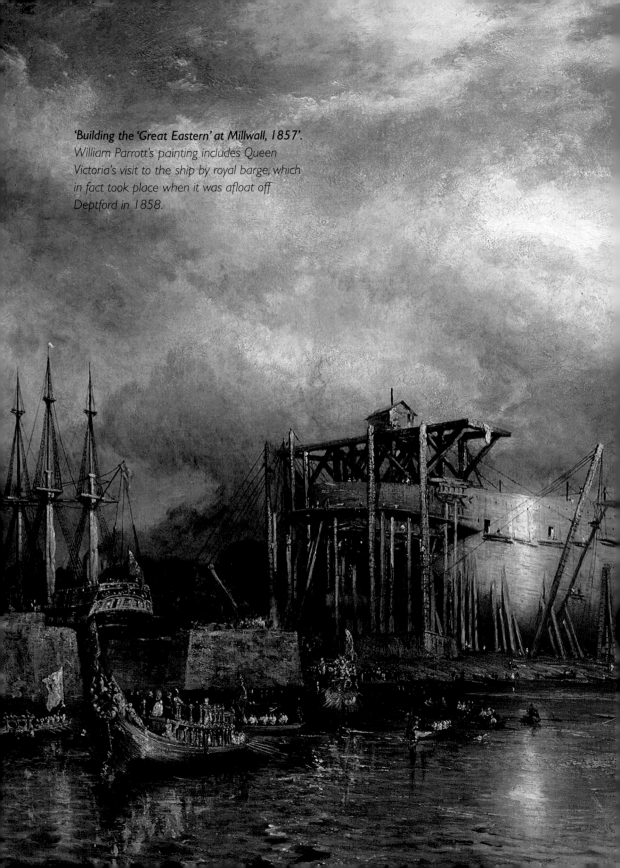

'Building the 'Great Eastern' at Millwall, 1857'.
William Parrott's painting includes Queen
Victoria's visit to the ship by royal barge, which
in fact took place when it was afloat off
Deptford in 1858.

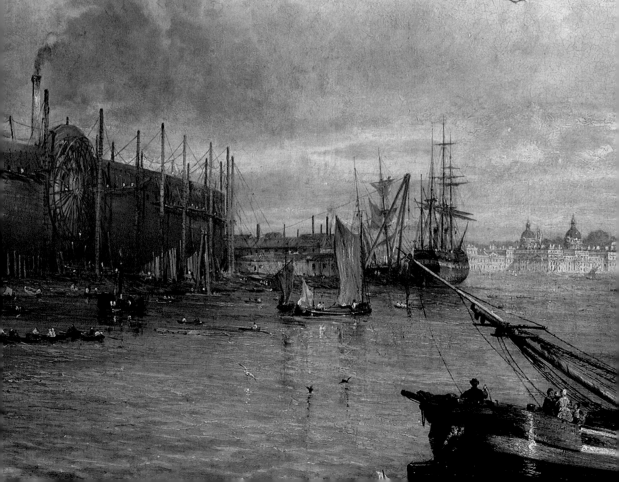

House of
Saxe-Coburg
and Gotha

Victoria
b. 1819, r. 1837–1901

Although Britain's worldwide colonial empire was already substantial and expanding by the time Victoria came to the throne, naval and mercantile sea-power consolidated it during her reign by the shift from wood and sail to steel and steam, a change itself symbolic of Britain's leadership in the Industrial Revolution.

For the monarch who (before Elizabeth II) reigned longer than any other, Victoria's own connection with Greenwich was minimal. She was first rowed down to Greenwich Hospital on the morning of 27 June 1840, two years after her coronation and marriage to Prince Albert of Saxe-Coburg and Gotha, but her journal note of the visit was barely more than domestic: 'Greenwich is a beautiful place and it was a very interesting sight, and I am so glad to have visited the Royal Hospital. In the Dining Halls, we tasted the soup prepared for the men, which was excellent.'

Queen Victoria (1819–1901); an early copy of a portrait of 1842 by Franz Xaver Winterhalter.

While she made a few other journeys down river later in the 1840s, including in Prince Frederick's Barge, and in 1858 to see Brunel's *Great Eastern* just after its launch at Millwall, that of 1840 seems to have been her only direct encounter with the Greenwich historic buildings.

Victoria and Prince Albert (1819–61); the queen was devastated by his early death from typhoid. His intelligence and reforming spirit also made it a national loss.

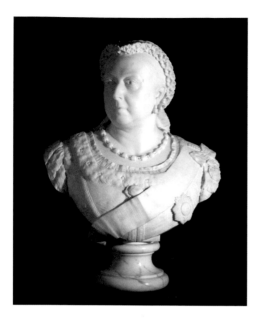

A bust of Queen Victoria by Joseph Edgar Boehm, 1874, later her Sculptor in Ordinary.

In 1892, seventy years after Greenwich Hospital had first taken responsibility for the Royal Naval Asylum in 1821, thereby creating the conjoined Hospital 'Schools' in the Queen's House and its added flanking wings, she granted them the unified title of 'Royal Hospital School', under which it still flourishes at Holbrook in Suffolk.

In 1894, she also approved a proposal to move Prince Frederick's Barge from loan to the South Kensington Museum to the Naval Gallery in the Painted Hall, but it did not happen: the barge only came to the NMM in 1951. She

did present two Chinese silk flags to the Naval Gallery in 1859, items passed on after capture in 1857 during the Second Opium War: one is of conventional form, showing a winged tiger, the other is the ceremonial parasol of a Chinese regional commander. It was Prince Albert, however, who gave the Gallery one of its most famous items.

In 1844, while Sir Nicholas Harris Nicolas was completing publication of his multi-volume edition of Nelson's letters, he learnt that the admiral's 'Trafalgar coat' had come to light. This is the uniform coat that Nelson was wearing in action on 21 October 1805 when shot by a French marksman. His sister-in-law lent it to Lady Hamilton for life, but she gave it and other Nelson items to one of her supporters, Alderman Joshua Jonathan Smith, to discharge a debt.

The left shoulder bears the fatal bullet hole and by 1844 Queen Victoria already had the bullet: William Beatty, *Victory's* surgeon, had extracted it during his autopsy on Nelson's body as the ship came up-Channel late in 1805. Part of the left epaulette, impacted on the lead ball, came out with it and Beatty preserved both in a glazed silver pendant. He carried this with him until he died in

1842, when his family presented it to the queen; it is still at Windsor Castle.

When Nicolas learnt that Smith's widow wished to sell the coat for £150 he wrote to the newspapers saying it should be saved for the nation. The matter soon came to Prince Albert's notice: he bought the coat and had it sent to the Naval Gallery as the appropriate national collection at the time. It was originally displayed in the Painted Hall in a special table case bearing a silver plaque recording the royal gift and left only twice before being transferred for care and display at the NMM in 1936. The first time was when Daniel Maclise RA asked to borrow it to make sketches in his studio for his vast fresco of the death of Nelson in the new House of Lords. Rather surprisingly, Greenwich Hospital seems to have agreed, and it was also lent to the enormous Royal Naval Exhibition at Chelsea in 1891 (item no. 3,206 in over 5,300). It has usually been central to the NMM Nelson displays and has only once gone elsewhere since: in 2013, in a spirit of modern Anglo-French amity, it was one of the highlights in an exhibition on Napoleon and Europe at the Musée de l'Armée in Paris.

Nelson's Trafalgar coat, purchased and presented to the Naval Gallery at Greenwich by Prince Albert in 1845. The fatal bullet hole is clear in the left shoulder.

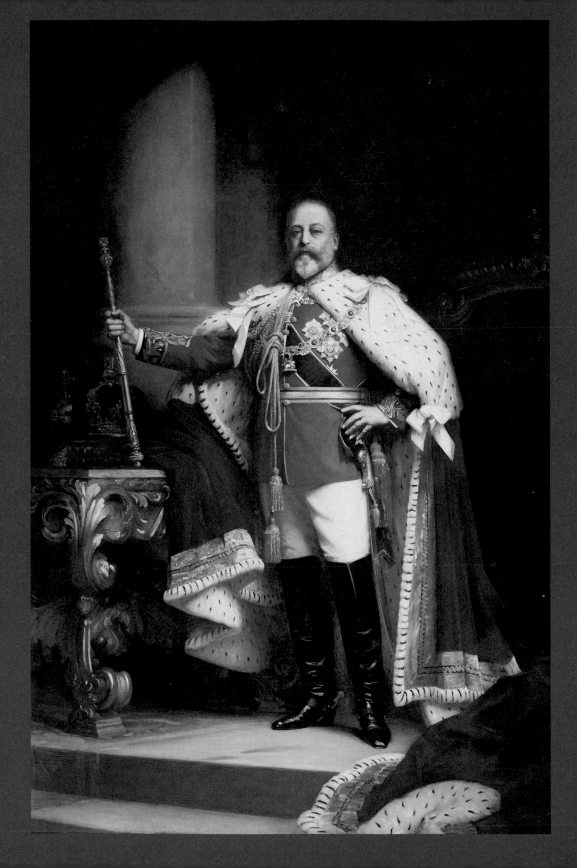

Edward VII
b. 1841, r. 1901–10

'Bertie' as Prince Albert Edward was known in his family, was the first recognizably modern British king. He was the second child of Victoria and Albert, after his studious elder sister (Victoria, Princess Royal), and a severe educational and moral disappointment to both. The queen blamed his behaviour for hastening the early death of his serious-minded father in 1861 and treated him as ill-suited to succeed her for most of his fifty-nine years as Prince of Wales, a span only surpassed by his great-great-grandson Charles in 2018.

Although he had a successful marriage to Princess Alexandra of Denmark from 1863, 'Bertie' had by then acquired lifelong tastes as a pleasure-loving womanizer. To more objective eyes than his parents', he had also begun to prove himself intelligent, well-informed and exceptionally good with people. He was the first British monarch who treated everyone he met,

Edward VII in coronation robes, by Luke Fildes RA, 1901. Fildes was knighted by the king in 1906.

irrespective of importance, with the same friendly courtesy; his children and grandchildren loved him and he was hugely popular with the public.

Abroad, on his near-worldwide travels before becoming king, and later, his diplomatic charm made him an unprecedented royal asset. For his time, he was also unusual in his lack of racial and religious prejudices, and several of his firm put-downs on such matters are recorded. Ironically, his English always had a German accent: he spoke that language and French fluently, and is usually remembered for his part in concluding the *entente cordiale* of 1904, formally ending centuries of Anglo-French hostility. Less happily, the one cousin he found incompatible was his elder sister Victoria's son, Kaiser Wilhelm II.

Edward left little trace at Greenwich but the fine wrought-iron gates of the NMM's Neptune Court bear the central initials 'ER', which suggests they were either made or altered after his accession in 1901. They are set in the preserved facade of what was originally 'Neptune's Hall',

'Edward, as Prince of Wales, with Princess Alexandra, at the Greenwich Hospital School Prize Day in 1890', from the Illustrated London News.

the 1873 gymnasium of the Hospital School (the iron-arched hall was removed in 1995–6). The School certainly had reason to remember him as Prince of Wales, since on 10 July 1890 he attended its annual prize-day with Princess Alexandra, taking the salute at the boys' parade in his honour from the terrace of the Queen's House. After lunch they both then presented prizes on the stage at the south end of the Hall, from which – before it became a display space – his grandson George VI also formally opened the NMM in 1937.

The Museum has three further unusual mementos of him, two from his childhood. First and best-known is the white-duck sailor suit made for him in 1846 by seamen on the Royal Yacht *Victoria & Albert*; this launched a civilian fashion – originally for children – which still recurs today. The second is a magnificent silver quintant (similar to a sextant) made for him by the noted instrument-maker, Janet Taylor, and shown at the Great Exhibition of 1851. Its frame is in the form of the heraldic Prince of Wales feathers and it was one

Silver-framed quintant; the maker, Janet Taylor, showed this at the Great Exhibition of 1851 before it was presented to the Prince of Wales.

of a number of items presented to the Museum by his daughter-in-law, Queen Mary, in 1936.

Finally, the Museum's only notable portrait of him is the figurehead of the *Edward VII*, a small yacht which he had built in 1904 for his grandchildren to sail on Virginia Water, near Windsor. They included the future Edward VIII and George VI. Though fairly crude, the image is the familiar bearded late-life one of a king so closely related to the other continental royal houses of his day that he was called the 'uncle of Europe'.

Prince Albert Edward's sailor suit, made for him on the royal yacht in 1846, when he was five.

HOUSE OF WINDSOR

FROM 1917

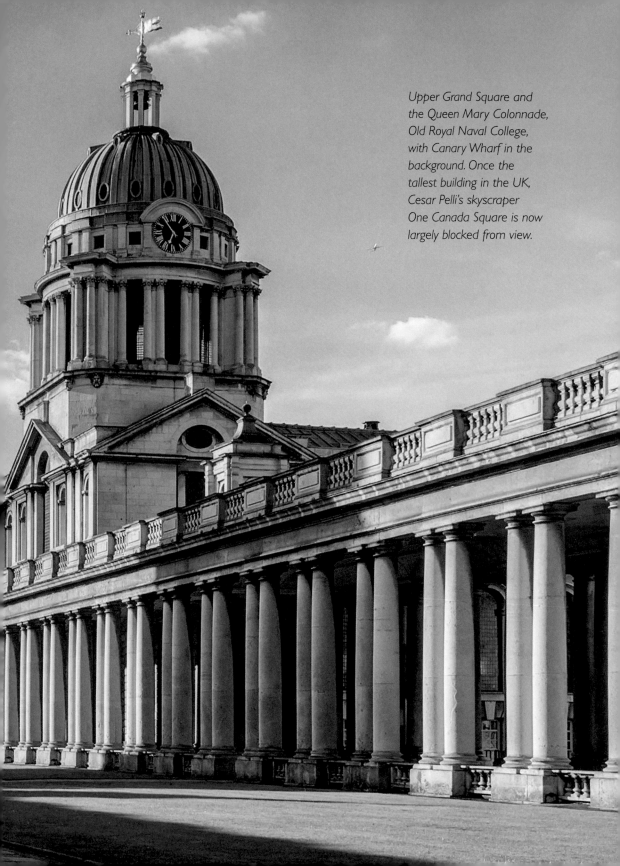

Upper Grand Square and the Queen Mary Colonnade, Old Royal Naval College, with Canary Wharf in the background. Once the tallest building in the UK, Cesar Pelli's skyscraper One Canada Square is now largely blocked from view.

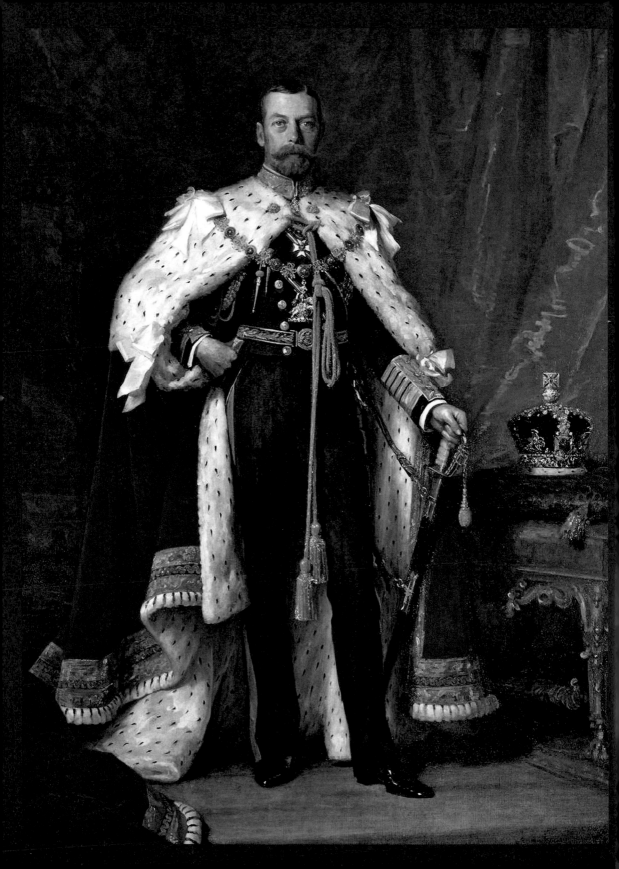

George V
b. 1865, r. 1910–36

George V and George VI (Prince Albert, Duke of York, before his accession) shared the misfortune of both being second sons who became king unexpectedly. In the latter case it was brutally sudden following the 1936 abdication of Edward VIII; in the former at longer notice, by the death from pneumonia in 1892, aged 28, of Prince Albert Victor, eldest son of the future Edward VII. Both George V and his second son – also 'Bertie' in the family, like his grandfather – therefore began with the expectation of forming their own careers as far as possible: both joined the Royal Navy and would have been happy just to remain royal dukes.

Princes Albert Victor and George trained together in the Navy for three years from 1877, travelling widely. George continued service on his own from 1883, much of it under his uncle Admiral Prince Alfred, Duke of Edinburgh,

George V, painted in coronation robes by Sir Luke Fildes in 1911, ten years after doing the same for his father.

and was captain of the protected cruiser *Melampus* when Albert Victor's death ended his seagoing career. This was a matter of personal regret. He was a competent, non-intellectual man whose leisure interests were game shooting and serious stamp-collecting. He was conservative, exacting in matters of dress, punctuality and good order, and well suited to structured service life.

His brother had died already engaged to Princess Victoria Mary of Teck (a distant cousin) but after she and George subsequently became close they were the ones who married in 1893. They chose Mary as her regnal name as Queen Consort, though she was privately called 'May', and it was a long and happy partnership. George was not personally expressive and their five sons and one daughter found him strict. Edward, Albert (George VI), and George, Duke of Kent, all spent more or less time in the Navy but only 'Bertie' with long term intention. Prince Henry, Duke of Gloucester, became a soldier and Prince John, the youngest boy, was never well and died aged thirteen in 1919.

George V, one of a set of 11 'toby' jugs of *First World War allied leaders, based on sketches by the political cartoonist Sir Francis Carruthers Gould.*

George V's reign was one of political turmoil at home and abroad, both before and after the First World War, during which he formally changed the dynastic family name from 'Saxe-Coburg and Gotha' to 'Windsor' (from 17 July 1917). His legacy was one of hard work as a stabilising influence and his family life was seen as a model of decent, upper-middle-class standards rather than aristocratic ones.

In 1877 he appears to have taken his naval entrance exam at the Royal Naval College in Greenwich. He was also briefly there again in 1884 when an acting sub-lieutenant but his later connections as king were slight. After the First World War, he certainly took an interest in the Society for Nautical Research's work to ensure the preservation of HMS *Victory* at Portsmouth, visited the ship in 1928 after that was achieved, and was also supportive of its next project to establish what formally became the National Maritime Museum in 1934.

In 1930 he offered Queen Mary II's shallop of 1689 as a gift for the projected museum. It had been the last historic royal barge in occasional use: Prince Frederick's had made its final voyage taking Prince Albert to open the London Coal Exchange in 1849. The shallop's last outing was on 4 August 1919, when it carried King George and Queen Mary in the Thames Peace Pageant held to mark the end, and fifth anniversary of the start, of the Great War.

The king did not live to see the Museum opened and the shallop only left storage near Windsor in 1953. After restoration at a Greenwich boatyard, its initial display was also at the first ever London Boat Show in December 1954,

George V on HMS Victory *at Portsmouth in 1928, after its restoration, speaking with marine painter W.L. Wyllie RA and other members of the Society for Nautical Research.*

before it joined Prince Frederick's Barge (which is still a royal loan) in a newly built NMM barge-house in 1955.

Queen Mary's contributions to Greenwich were more material and continued nearly to the end of her life (1867–1953). Her interest in nautical matters partly supported her husband's but she was also a significant collector herself, including of 'Nelsoniana'. She gave six such items to the former Naval Museum in the Naval College in 1930, and many more directly to the NMM from 1933 on: most came in 1936, the year in which she was widowed, and then more occasionally to 1951.

The 1936 gifts included navigational instruments used by George V's uncle, and former commander Admiral Prince Alfred, as well as Edward VII's silver quintant, already mentioned. She also made three further visits to the Museum with other family members after attending its opening in 1937. The last, with her daughter Mary (Princess Royal and Countess of Harewood), was in 1948 to see an exhibition of Nelsoniana recently acquired from his family. Her interest was warmly remembered: in 1960 one of the founding trustees told her granddaughter, the present queen, that she should really have been titled 'Royal Visitor with a capital V!'

Edward VIII
b. 1894, r. January–December 1936, d. 1972

George V died on 20 January 1936 and his never-crowned eldest son, Edward VIII, abdicated on 11 December. As Prince of Wales, Edward had only appeared at Greenwich on one notable public occasion, to attend the great 'Greenwich Night Pageant' of 16–24 June 1933.

Edward VIII as a naval cadet. He attended the RN Colleges at Osborne and Dartmouth from 1907 but was only briefly a serving midshipman in the battleship Hindustan, *1910–11.*

Conceived by Admiral Barry Domvile, President of the Royal Naval College, and scripted by the historian Arthur Bryant, this summer-evening spectacle was mounted with a cast of about 1,200 (mostly amateur and local), rousing music and innovative technical effects, in the upper Grand Square of the College. A 12,000-seat temporary stand – the largest yet built in the UK – backed onto the river in the lower square.

The Greenwich pageant was one of an international fashion in such historical celebrations from around 1900 to the Second World War, bolstering local and national identities in an era of major political upheavals. The spectacular setting and Domvile's recognition that 'the history of Greenwich is the History of England' were, however, key elements in making it exceptional. It had wide press coverage, over 80,000 people saw it, one night's musical finale was broadcast on BBC radio, and over £3,000 (about £110,000 today) was raised for naval and local charities. The theme was the maritime glory of Britain, a tale of imperial seaborne heroism from the age of

Elizabeth I through Nelson and up to date, although exclusion of the naval successes of Cromwell's 1650s republic was a point of Labour Party complaint in Parliament.

Health concerns prevented George V attending but royalty present on various nights included Queen Mary and the Princess Royal, Prince Henry, Duke of Gloucester, King Faisal of Iraq (as part of a state visit) and ex-King Alfonso of Spain. HRH Prince Edward was guest of honour on Friday 23 June – also his 39th birthday – when he dined with Domvile before the performance. Cabinet ministers and other VIPs also came.

Domvile and Bryant's vision was strongly patriotic but both also sympathised with early 1930s German national resurgence and, with hindsight, their Greenwich triumph has also been called 'the nearest England came to fascist theatre'. Domvile was knighted on retiring from the Navy in 1934 but he and his German-born wife – whose organisational work had greatly aided the pageant – then fell so seriously under Hitler's spell that both were interned for much of the Second World War. The Domviles' subsequent political disgrace has understandably obliterated their credit for pioneering popular and dramatic interpretation of the

Admiral Domvile's badge as President of the organizing committee for the Greenwich Pageant.

historical and naval narrative that still underpins much of the 'Maritime Greenwich' visitor economy, but pioneers they certainly were.

After abdicating and moving to France as Duke of Windsor, Prince Edward's reputation was also damaged by accepting Nazi overtures and visiting Germany, though he escaped later German plans to seize him as a wartime political pawn. Bryant – an ever-readable and popular writer – quickly redeemed his pre-war political naivety. Admired by Prime Ministers including Churchill, Harold Wilson and Margaret Thatcher, he was appointed CBE in 1949, knighted in 1954 and made a Companion of Honour in 1967. He died in 1985.

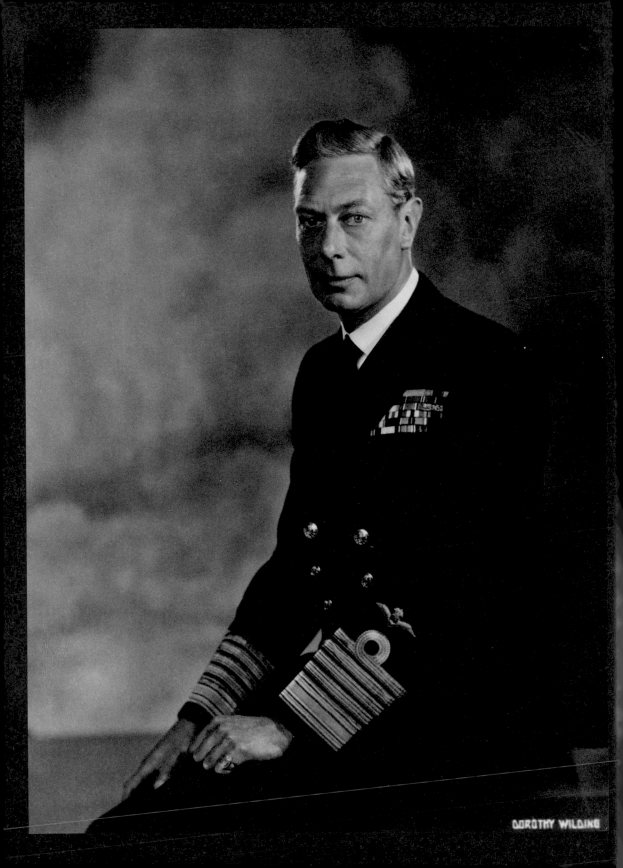

DOROTHY WILDING

George VI
b. 1895, r.1936–52

George V and Queen Mary set the modern image of monarch and consort as a working family pair, a pattern strengthened by George VI and Queen Elizabeth (1900–2002), the latter still very much in general living memory.

Prince Albert Frederick Arthur George chose to reign under his last forename to maintain continuity with his father. In contrast to his elder brother, Edward, he had been a shy child, often unwell and with a stammer that he only mastered with therapy in the 1920s. From 1909 he trained for the Navy and three years after joining it in 1913 was mentioned in dispatches while a lieutenant in HMS *Collingwood* at the Battle of Jutland.

Surgery for a stomach ulcer in 1917 prompted a switch the following year to the newly formed RAF and he was the first member of the Royal Family to qualify as a pilot, before serving as a staff officer in France at the end of the war. He then briefly attended Trinity College, Cambridge, before being made Duke of York in 1920 and soon becoming known for his interest in social and industrial matters.

George VI, photographed by Dorothy Wilding in 1946. Of his nearly ten years as king by then, the Second World War (1939–45) had filled six.

A childhood photograph of (left) George VI, (right) Edward VIII and (bottom) their sister Princess Mary (1897–1965).

In 1923 he married Lady Elizabeth Bowes-Lyon, who would thereby become the first queen consort not herself a princess since Henry VIII's last wife, Catherine Parr, in 1543. This, of course, was caused by the unexpected abdication of Edward VIII in 1936, when the Duke and his daughters, the Princesses Elizabeth and Margaret (b. 1926 and 1930) were already next in line, given that Edward had no children.

The new king and queen are best remembered for their fortitude during the Second World War (1939–45) when both refused to leave London. This had a huge effect in maintaining civilian morale but wartime and post-war strains in a role he had not expected did not help the king's health; nor did his heavy cigarette-smoking. His death aged 56, from a heart attack in his sleep in February 1952, was more a shock to the public than his doctors, since he had then already lost a lung to cancer.

A decision to move the Royal Hospital School from Greenwich to Holbrook, Suffolk, had been made while

Queen Mary arrives for the royal opening of the National Maritime Museum on 27 April 1937. Lord Stanhope, the Museum's first Chairman of Trustees, is on the right.

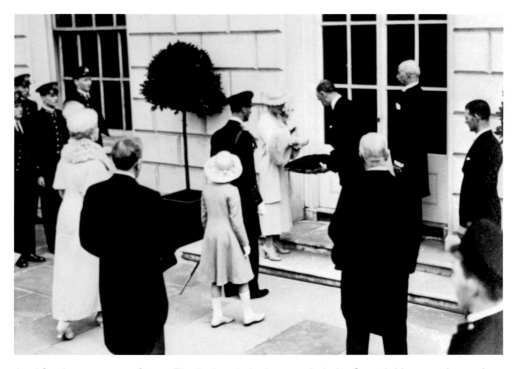

Lord Stanhope presents Queen Elizabeth with the key to unlock the Queen's House at the royal opening of the Museum in 1937.

he was Duke of York and on 26 October 1928 he laid the foundation stone of its new premises there. The move took place in 1933, with conversion of the former school buildings at Greenwich into the National Maritime Museum starting after its formal creation by Act of Parliament in July 1934. Three years later, on 27 April 1937 – just over four months after the abdication – the Museum's opening was staged as the first major public event of the new reign, to help restore public confidence in the monarchy.

Preceding the Coronation (on 12 May) George VI, Queen Elizabeth and Princess Elizabeth come down to Greenwich by river, with crowds on the banks and bridges of the Thames cheering as they passed, to land at the water stairs of the Royal Naval College. It was the first-ever public engagement for the princess, as a birthday treat: she was eleven on 21 April. Queen Mary arrived ahead of them at the Museum by road.

After Lord Stanhope, Chairman of the Museum Trustees and Civil Lord

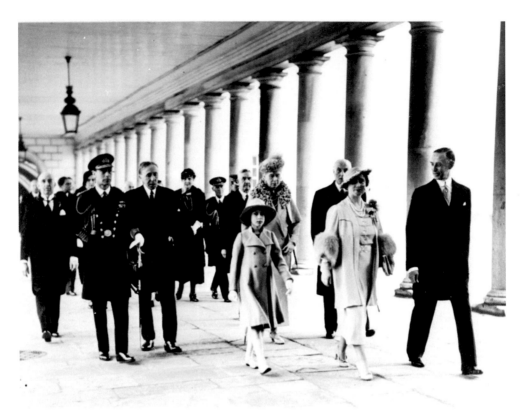

The royal party walking through the Colonnade with Sir Geoffrey Callender (the Museum's first Director, knighted in 1938), at the far left, behind George VI.

of the Admiralty, received the King and Queen Elizabeth at the steps of the Queen's House, the latter unlocked the north door to its Great Hall with a special golden key and the whole entourage passed through to the central Colonnade. A well-known photograph shows them all walking along it to the Museum's Neptune Hall – the king in the uniform of Admiral of the Fleet – for public welcome before a large invited audience.

There he gave a short opening speech from the old gymnasium stage at the south end. A rather stiff 'family photo' was finally taken beside a model of Charles I's *Sovereign of the Seas* of 1637 (i.e. 300 years before, though the model itself was built for the Great Exhibition of 1851). At the end of the visit the royal party appeared on the south loggia of the Queen's House, waving to a cheering crowd in Greenwich Park.

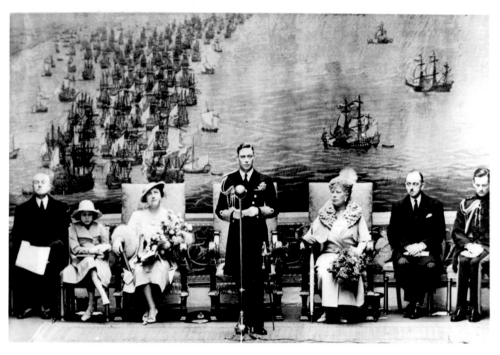

The King's opening speech in front of the Solebay Tapestry, designed by the van de Veldes.

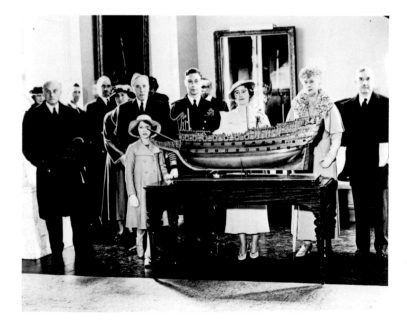

(L. to R.) Sir Samuel Hoare (First Lord of the Admiralty); Admiral Sir George Hope (President, Society for Nautical Research) behind Princess Elizabeth; George VI, Queen Elizabeth, Queen Mary and Sir James Caird, the main National Maritime Museum benefactor.

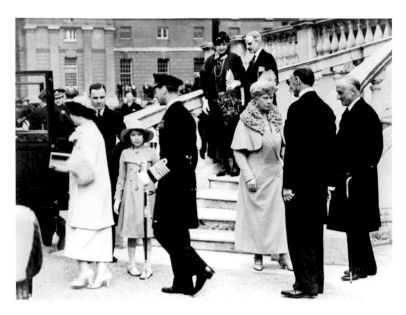

Departure from the steps of the Queen's House.

Seven-year-old Princess Margaret had not been pleased to be left out, as too young, but her grandmother, Queen Mary, made up for that when she brought both sisters back for a private Museum visit in June 1938. Reginald Lowen, in effect its deputy director, found himself carrying Margaret so she could see into some of the display cases.

The move of Greenwich Hospital paintings from the old Naval Gallery in the Painted Hall to the Museum meant that after 1936 the Hall could be restored to its original splendour. For the first time since 1707 it again became a dining 'mess' but now for officers attending the Royal Naval College, rather than Greenwich Pensioners. The reconversion included unblocking all the tall lower windows, bricked-up and panelled over in the nineteenth century; inserting stairs down from the vestibule to the undercroft areas below; replacing heating and lighting, and strengthening the Painted Hall ceiling (though the main twentieth-century restoration followed in 1957–60). All this done, the College began use of the Hall as a refectory from 1 May 1939 – some sixty years after first requesting it in 1878.

On 11 July, again in full naval uniform and accompanied similarly by his brother the Duke of Kent, George VI once more came down by fast launch to mark the restoration by dining in the Hall with 367 naval officers and other VIP guests: the former were chosen partly by seniority

and partly by ballot. It appears to have been the first time a reigning monarch ever dined there and was preceded by the king knighting the College President, Vice-Admiral Charles Kennedy-Purvis:

There were no speeches, and afterwards the King moved around the Mess rooms [below] talking informally with the officers, joining in the sub-lieutenants sing-songs and watching games of billiards. A little after midnight, to the cheers of his officers, the King departed by car for Buckingham Palace... Yet for all that was new on that warm summer evening, few... present would have believed that this grand event represented anything other than the end of an era. The country was now less than two months away from a war, with some fifteen thousand [naval] reservists already called up ... and the last of many detailed measures to ensure that the Royal Navy's 'front line' was ready for battle were being implemented...

(Harry Dickinson, *Wisdom and War: The Royal Naval College Greenwich, 1873–1998*, Ashgate 2012, pp.170–71).

Like Queen Mary before her, Queen Elizabeth The Queen Mother, who so far holds the record for British royal longevity (she died aged 101), made a few private visits to the NMM in her fifty-year

The reverse of this silver medal commemorates the royal opening of the National Maritime Museum in 1937.

widowhood. One afternoon around 1980 I was working in the Library when she passed through, in characteristic broad hat and elegant coat, trailing a small escort of Museum staff on the way to tea in the Director's office. A middle-aged public reader, head-down in research opposite, was startled out of it when she suddenly stopped to ask what he was doing: he stumbled to his feet to answer and after a brief exchange and her usual warm smile of thanks, she led the convoy on. Looking dazed but pleased, he sat back to work and I expect told the tale ever after; and it was the only time I ever saw her in person.

Elizabeth II
b. 1926, r. 1952–

The opening of the NMM in 1937 launched a period that has seen a greater royal presence in historic Greenwich than since the late-Stuart seventeenth century. Much of the NMM collection left London during the Second World War and from 1941 parts of the buildings were requisitioned for wartime purposes. The Admiralty's 'M Branch' (the 'secret books' division) took over the as yet unconverted east wing, and both Naval Constructors and a large contingent of 'Wrens' (the Womens' Royal Naval Service) were billeted in west wing areas. The Wrens later moved into the Queen's House, which narrowly avoided destruction when an incendiary bomb started a fire in the roof. Other bomb damage was mainly from external blast and quickly repaired.

Elizabeth II by Pietro Annigoni, 1970.
Annigoni painted this for the National Portrait Gallery in deliberate contrast to his romantic and more famous earlier portrait of 1954. His aim was not to show her 'as a film star [but]…as a monarch, alone in the problems of her responsibility'. Unsurprisingly, it proved more controversial.

Post-war re-opening from 1945 was inevitably slow and also delayed by the sudden death of the first director, Sir Geoffrey Callender, aged 70, in his Museum office in November 1946; fortunately the influential founding Chairman of Trustees, Lord Stanhope, remained a figure of continuity until 1959.

In 1947 Princess Elizabeth married Prince Philip, the present Duke of Edinburgh, who also received the title of Baron Greenwich at marriage. In the following year both came for him to receive the Freedom of the Borough and also made a visit to the Museum, shortly after his appointment as one of its Trustees.

He thereafter showed a close and ever-incisive interest, especially in matters of 'modern collecting' for just over half a century, remaining on the Board far longer than usual at his own request: other things allowing – including his last active service as a Naval officer until 1952 – he attended at least one meeting annually, as well as coming on many other occasions. On standing down in 2000 he instead became – and remains – the Museum's first Royal Patron.

Princess Elizabeth herself made just one more visit to the Museum after 1938 before becoming queen. On 3 July 1951 she opened the first public galleries in the east wing. These brought the subjects displayed into the nineteenth and twentieth centuries, but had to wait until Admiralty 'M Branch' moved out in 1947, its only legacy today being a still-useful strong-room. Her first visit as queen, with Prince Philip, was on 6 July 1960 to open Flamsteed House at the Royal Observatory, after that formally became part of the Museum.

Between these two occasions they had both also come when she opened *Cutty Sark* to the public in June 1957, three years after it was floated into its Greenwich dry-dock for restoration and

preservation there. This was a project in which the Duke played a major role as Patron of the Cutty Sark Preservation Society, founded in 1952, above all in helping raise the necessary funds; he was to do so again in support of its recent and even more massive conservation.

Another notable royal event was when Francis Chichester returned from his single-handed round-the-world-voyage in the ketch *Gypsy Moth IV* in June 1967. Six weeks later on a sunny July day in the Grand Square of the Royal Naval College, and watched by a large crowd, Her Majesty knighted him with the same sword used by Elizabeth I to knight Sir Francis Drake on board the *Golden Hind* at Deptford in 1581, after his famed circumnavigation.

Prince Philip arrives to open the Octagon Room at the Observatory in 1951, while still a serving Royal Naval officer.

Princess Elizabeth at the opening of the NMM East Wing galleries, 3 July 1951, with Lord Stanhope and (right) 'Reg' Lowen, pillar of its general early administration.

The Cutty Sark today. As part of its second restoration in 2006–12, the ship was suspended above its dry-dock to reduce stress on the 1869 hull structure.

Among her nine later visits (so far) was a private one to the NMM exhibition marking the 400th anniversary of the Spanish Armada in 1988, and another to open that commemorating the death of Elizabeth I in 2003. Most have been with Prince Philip, including the last in 2012 to relaunch the *Cutty Sark* after its second restoration and open the *Royal River* exhibition celebrating her Diamond Jubilee. At the Silver Jubilee in 1977 she had embarked at Greenwich for the river pageant held to celebrate that and, ten years later, was on the P&O cruise liner *Pacific Princess* in the river to watch a spectacular *son et lumière* over the Royal Naval College and Park to mark the 150th anniversary of P&O.

The London Olympics of 2012 made similarly dramatic use of the Park, with the equestrian events held in a temporary arena south of the Queen's House, itself used as the Olympic VIP centre. They not only saw much Royal Family attendance but Zara Tindall, the queen's granddaughter, competed as one of the British team. When she won a silver medal it was presented by

HM The Queen first opened Cutty Sark to the public at Greenwich on 25 June 1957. She did so again on 25 April 2012, as shown here.

her mother Princess Anne, the Princess Royal, who was also in the British team at the Montreal Olympics of 1976 and, in recent years, has been the most frequent royal visitor to Greenwich.

Before the Royal Naval College closed as a training establishment in 1998, HRH The Prince of Wales, Prince Andrew – and Prince Philip long before them – attended courses there while serving as naval officers. Prince Andrew became Patron of Greenwich Hospital, the royal charity which is still the main 'landlord' in the town centre in 1994, and was for some years also an NMM Trustee from 1995. HRH The Duke of Glouces-ter (an architect by profession) is Patron of the Greenwich Foundation for the Old Royal Naval College; HRH The Duke of Kent that of Trinity La-ban College of Music and Dance, which occupies its King Charles Court; and, more recently, HRH The Duchess of Cornwall became Patron of the Fan

Museum, Greenwich, another internationally important collection of its sort.

Since the reorganisation of London local government in 1964, the borough of Greenwich has been far larger than just the historic town, Park and fairly close surrounding area. It now includes Woolwich and Eltham as well, which have their own long royal associations. In Woolwich, the most significant are with the Royal Artillery, other army units now based there, and the former Royal Arsenal and Royal Dockyard. Eltham holds the much older and very substantial remains of Eltham Palace (now in the care of English Heritage), including its intact fifteenth-century Great Hall.

At Greenwich the buried foundations of medieval Placentia and the Tudor palace which replaced it still lie under Wren's Old Royal Naval College, though the major archaeological work done on them in 1970--71 remains largely unpublished. It is this history, literally 'in depth', as well as visible in the great seventeenth- and eighteenth-century buildings – created under royal patronage for naval welfare, education and the advancement of navigation – that led to 'historic Greenwich' being inscribed as a UNESCO World Heritage Site in December 1997.

These associations, with those of Woolwich and Eltham, were further recognised in 2010, when the queen granted Royal Borough status to Greenwich as a whole, to mark and take effect at her Diamond Jubilee in 2012. It became only the third in Greater London: the others are Kingston (by prescriptive right, confirmed by George V in 1927 as coronation seat of the Anglo-Saxon kings) and Kensington and Chelsea, long a borough of ongoing royal residence. Greenwich finally joined them for the 'royal reasons' largely relating to the modern World Heritage Site that have been sketched here.

Although time-keeping is now co-ordinated in Paris using an internationally dispersed set of atomic clocks, Greenwich Time, as defined on Longitude 0° at the Royal Observatory, still sets that for the world. It does so by international agreement of 1884, when Queen Victoria still had fifteen of her sixty-three years on the throne ahead. In 2015 her great-great-granddaughter, Her Majesty Queen Elizabeth II, matched and has now well exceeded that record as the longest-reigning British monarch. How the story of Greenwich will continue when her page of royal history turns to the next will be for some future book to tell: for now 'God save The Queen!'

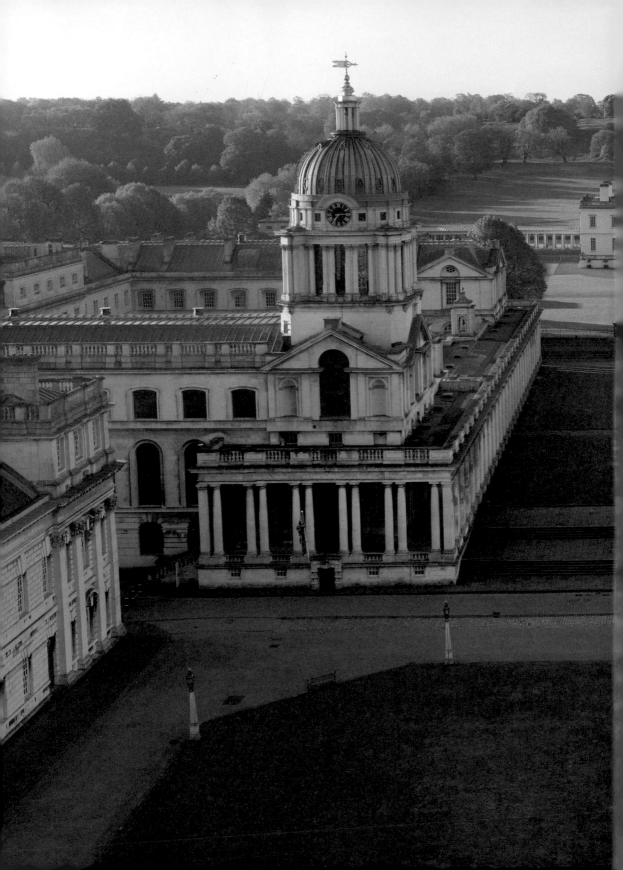

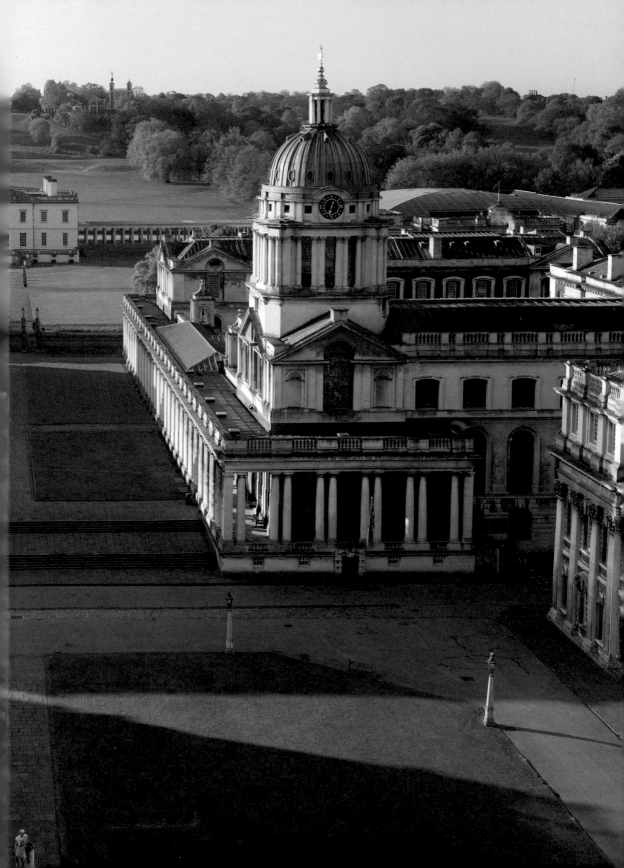

Appendix:
List of Monarchs, 1066–1485

A few of the pre-Tudor kings below appear early in this book. This list completes the total of 41 to date since the Norman Conquest. Heirs were normally eldest surviving legitimate sons: [U] = accession by usurpation; m. = married; 9c. (for example) = number of children, if any.

House of Normandy

William I (the Conqueror), b. *c.*1028, r. 1066–87: m. Matilda of Flanders, 9c.

William II (Rufus), b. *c.*1056, r. 1087–1100 (killed by an arrow in a New Forest hunting accident): 2nd son of William I and his chosen successor. His elder brother Robert, Duke of Normandy (d. 1134), was subsequently an unsuccessful claimant.

Henry I (Beauclerc), b. *c.*1068/9, r. 1100–35: 3rd son of William I; m. (1) Matilda of Scotland, (2) Adeliza of Louvain. 2c. by Matilda only: William, drowned in loss of the *White Ship*, 1120, and Matilda (1102–67), who m. (1) Henry V of Germany and Holy Roman Emperor, (2) Geoffrey 'Plantagenet' of Anjou.

House of Blois

Stephen, b. *c.*1096, r. [U] 1135–54: cousin of Matilda (latterly of Anjou); m. Matilda of Boulogne, 5c. Legally designated heir, Henry, eldest son of Matilda of Anjou: she invaded and held England, 1141–8, but did not gain support to take the crown.

House of Anjou

Henry II (Curtmantle), b. 1133, r. 1154–89: m. Eleanor of Aquitaine, 8c.

Richard I (the Lionheart), b. 1157, r. 1189–99 (mortally wounded at the siege of Châlus, France): 3rd son of above; m. Berengaria of Navarre.

John (Lackland), b. 1167, r. 1199–1216: 5th son of Henry II; m. (1) Isabella of Gloucester, (2) Isabella of Angoulême, 5c.

House of Plantagenet
(name first adopted by Richard III)

Henry III (of Winchester), b.1207, r. 1216–72: m. Eleanor of Provence, 5c.

Edward I (Longshanks), b. 1239, r. 1272–1307: m. (1) Eleanor of Castile, 16c., (2) Margaret of France, 3c.

Edward II (of Caernarfon), b. 1284, r. 1307–27 (murdered at Berkeley Castle): 4th son of above; m. Isabella of France, 4c.

Edward III, b. 1312, r. 1327–77: m. Philippa of Hainault, 13c. of whom the eldest son was Edward, the 'Black Prince' (1330–76).

Richard II, b. 1367, r. 1377–99 (died suspiciously in captivity at Pontefract Castle): grandson of Edward III and son of the 'Black Prince'; m. (1) Anne of Bohemia, (2) Isabella of Valois.

(Plantagenet cadet)
House of Lancaster

Henry IV (of Bolingbroke), b. 1367, r. [U] 1399–1413: son of John of Gaunt, Duke of Lancaster, 4th son of Edward III; m. (1) Mary de Bohun, 6c., (2) Joan of Navarre.

Henry V, b. 1386, r. 1413–22: m. Catherine of Valois, 1c.

Henry VI, b. 1421, *1st r.* 1422–61: m. Margaret of Anjou, 1c.

(Plantagenet cadet)
House of York

Edward IV, b. 1442, *1st r.* [U] 1461–70: great-great-grandson of Edward III; m. Elizabeth Woodville, 10c.

(Restored) House of Lancaster

Henry VI, *2nd r.* 1470–1 (191 days, then murdered in the Tower of London).

(Restored) House of York

Edward IV, *2nd r.* 1471–83.

Edward V, b. 1470, r. 1483 (78 days to 25 June, then disappeared in the Tower of London, presumed murdered).

Richard III, b. 1452, great-great-grandson of Edward III and 4th Duke of Gloucester, r. [U and by Parliamentary title] 1483–5: killed in battle at Bosworth against Henry Tudor, subsequently Henry VII: m. Anne Neville, 1c.

This traditional mnemonic is a way of remembering all kings and queens regnant of England since 1066:

Willie, Willie, Harry, Stee,
Harry, Dick, John, Harry three;
One, two, three Neds, Richard two,
Harrys four, five, six… then who?
Neds four, five and Dick the Bad,
Harrys twain, Ned six (the lad);
Mary, Bessie, James the Vain,
Charlie, Charlie, James again;
William-and-Mary, Anne, then – gloria! –
Four Georges, William and Victoria;
Ned and George, again twice o'er,
Then Elizabeth once more.

Further Reading

Clive Aslet *The Story of Greenwich* (Fourth Estate; 1999)

John Bold *Greenwich: an architectural history of the Royal Hospital for Seamen and the Queen's House* (Yale University Press; 2000)

Emma Hanna 'Patriotism and pageantry: Representations of Britain's Naval Past at the Greenwich Night Pageant, 1933', in Q. Colville and J. Davey (eds) *A New Naval History* (Manchester University Press; 2018)

Kevin Littlewood and Beverley Butler *Of Ships and Stars: Maritime Heritage and the Founding of the National Maritime Museum, Greenwich* (Athlone/National Maritime Museum; 1998)

Beryl Platts *A History of Greenwich* (2nd ed., David & Charles; 1973)

Simon Thurley *The Royal Palaces of Tudor England* (Yale University Press; 1993)

Simon Thurley *Houses of Power: The Places That Shaped the Tudor World* (Bantam; 2017)

Pieter van der Merwe *A Refuge for All: A Short History of Greenwich Hospital* (2nd ed., Greenwich Hospital; 2010)

Pieter van der Merwe 'A proud monument of the glory of England: The Greenwich Hospital Collection', in G. Quilley (ed.) *Art for the Nation* (National Maritime Museum; 2006)

Pieter van der Merwe *The Queen's House* (2nd ed., Scala; 2017)

A.D. Webster *Greenwich Park: Its History and Associations* (Conway Maritime Press reprint; 1971)

Acknowledgements

Eleanor Harris, then Director of Visitor Experience and Enterprises at Royal Museums Greenwich, suggested the concept for this book and that I write it. I am grateful to her on both counts (though wish I'd thought of it myself) and to Sarah Connelly of the in-house publications team for efficiently managing its production, not least given this has largely been done during the 2020 coronavirus 'lockdown'. Her work has included obtaining such images as the RMG Picture Library could not supply and we are both grateful to the providers for their use. Robert Blyth (Senior Curator, RMG) and Julian Watson (formerly Greenwich Local History Librarian) both kindly read the draft text and assisted in other ways, and I am also grateful to Jane Sidell (Historic England) and Julian Bowsher (Museum of London Archaeology) for advice on early parts. Everyone who has written on Greenwich history in the last fifty years owes a debt to the late Beryl Platts (1913–2018): despite being near neighbours for most of them, we never met but it is also a pleasure to thank her daughter, Elizabeth Pearcey, for her help.

Index

Anjou, House of 11, 168
Anne 98–101
 art donations to Greenwich Hospital 100
 Longitude Act 101
Anne of Denmark 56–9
 commissions Queen's House 59
 death 60
 masque for, at Greenwich 59

Blois, House of 168

Charles I 62–9
 art patronage and collection 63–4, 67
 developing Queen's House 65–9
 diplomacy at Greenwich 64
 execution 64, 69
 marriage 64
Charles II 72–83
 adapts Queen's House 73–4
 building new palace at Greenwich 76
 construction of Royal Observatory 82–3
 demolition of old palace and castle
 at Greenwich 74
 grants use of Queen's House to others 79–80
 restoration 73
 using Greenwich for munitions testing 77
 yacht racing off Greenwich 78
Commonwealth 70–1
Cutty Sark 162, 163, 164

Edward VI 34–7
 activities at Greenwich 35
 birth 35
 death at Greenwich 36
Edward VII 140–3
 objects related in National Maritime
 Museum 142–3

Edward VIII 150–1
 Greenwich Night Pageant 150–1
Elizabeth I 42–9
 activities at Greenwich 43, 44
 birth at Greenwich 31
 closing Greenwich friary 47
 death 49
 Francis Drake at Greenwich 45
 gardens at Greenwich 48
 renovating palace at Greenwich 47–8
 Spanish Armada 46–7
 Walter Ralegh at Greenwich 45
Elizabeth II 160–5
 grants Greenwich royal borough status 165
 opening *Cutty Sark* to public 162, 163, 164
 visits to National Maritime Museum
 155–8, 162–3

Flamsteed, John 51, 53, 81–2, 83, 162
Frederick, Prince of Wales, see George II

George I 104–7
George II and Frederick, Prince of Wales 108–13
 depictions in Painted Hall 109
 funding Greenwich Hospital 110
 Prince Frederick's barge 109, 137, 138
George III 114–19
 death of Horatio Nelson 119
 support for natural sciences 115–17
George IV 120–9
 and J.M.W. Turner's *Trafalgar* 125–7, 129
 Queen Caroline at Greenwich 121
 supports National Gallery of Naval Art
 123–5

George V 146–9
 naval entrance exam at Greenwich 148
 support for establishing National Maritime
 Museum 148
George VI 152–9
 lays foundation of new Royal Hospital
 School 154–5
 opening of National Maritime Museum
 155–7
Greenwich Castle 50–1
Greenwich friars 33, 39–40, 47
Greenwich Hospital
 acquisition of Queen's House 138
 design by Christopher Wren 77
 foundation under Mary II 87, 95–6
 funding from George II 106, 110
 increased demand due to French Wars 124
 interest from William IV 132
 plan for Royal Hospital for Seamen by
 James II 87, 89
 support from Queen Anne's husband 99
Grey, Lady Jane 36, 39

Hanover, House of 102–33
 George I 104–7
 George II 108–13
 Frederick, Prince of Wales 108–13
 George III 114–19
 George IV 120–9
 William IV 130–3
Henrietta Maria 64–9
 Queen's House adaptations for, 65–7, 73–4
Henry VII 22–5
 building new palace at Greenwich 23
 coronation 23
 death 25
 defeat of Richard III 23
 end of Wars of the Roses 23

Henry VIII 26–32
 birth at Greenwich 25
 coronation 25
 death 32
 establishes armoury at Greenwich 30
 expands palace at Greenwich 29
 founding of Royal Navy 29
 jousting at Greenwich 27, 29
 marriages 27, 30–2

James I (VI of Scotland) 54–61
 builds wall round Park 14
 improvements to palace at Greenwich 56
 marriage 56
 masques at Whitehall 58
 union of English and Scottish crowns 55
James II 84–9
 plan for Royal Hospital for Seamen 87, 89
Jones, Inigo 58–61, 65–7

Lancaster, House of 12, 169

Mary I 38–40
 birth at Greenwich 31
 death 40
 reinstating friary at Greenwich 39–40
Mary, Queen of Scots 35, 43, 55

National Maritime Museum
 contributions from Queen Mary 149
 conversion of Royal Hospital School 155
 during Second World War 171
 Nelson's Trafalgar coat 139
 opening by George VI 155–7, 159
 Prince Frederick's barge 138
 support of George V 148
Nelson, Horatio 119, 131, 133, 138–9, 149
Normandy, House of 10, 11, 168

Painted Hall of Greenwich Hospital 90–3, 158–9

Plantagenet, House of 12, 15–18, 168–9

Queen's House 59–60, 65–9
 adaptation under Charles II 73–4
 artwork from Charles I 64
 commissioning by Anne of Denmark 59–60
 construction 32
 development under Charles I 65–9
 during Second World War 161
 Olympic VIP centre 163
 residence of Rangers of Greenwich Park 100, 111
 transfer to Greenwich Hospital School 121

Richard III 16, 18, 23
Roman Greenwich 9
Royal Observatory
 construction under Charles II 82–3
 demolition of Greenwich Castle 51
 Greenwich time 83, 165
 role under George III 116

Saxe-Coburg and Gotha, House of 134–43
 Victoria 136–9
 Edward VII 140–3
Saxon , Norman, Angevin and Plantagenet Greenwich 10–18
Stuart, House of 52–101
 James VI and I 54–61
 Charles I 62–9
 Charles II 72–83

James II 84–9
William III (Prince of Orange) 94–7
Mary II 94–7
Anne 98–101

Tudor, House of 20–49
 Henry VII 22–5
 Henry VIII 26–32
 Edward VI 34–7
 Mary I 38–40
 Elizabeth I 42–9

Victoria 136–9
 donations to Naval Gallery 138–9

Vikings at Greenwich 9

William III and Mary II 94–7
 founding Royal Hospital for Seamen 95–6
William IV 130–3
 donations to Naval Gallery 133
 naval career 131
 visits to Greenwich Hospital 132
Windsor, House of 144–65
 George V 146–9
 Edward VIII 150–1
 George VI 152–9
 Elizabeth II 160–5
Wren, Christopher
 Greenwich Hospital 77, 96, 99, 110, 123
 Royal Observatory 82

York, House of 16, 169

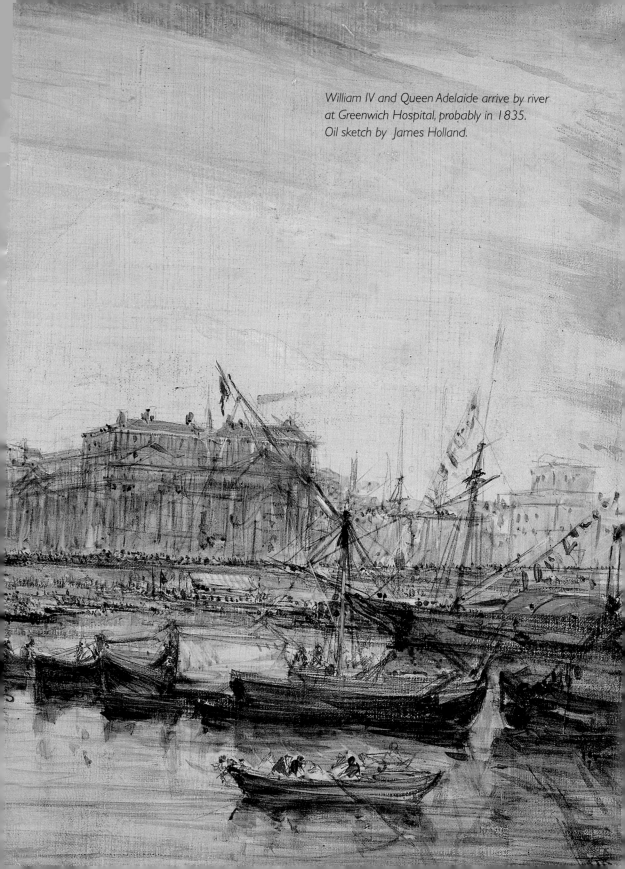

William IV and Queen Adelaide arrive by river at Greenwich Hospital, probably in 1835. Oil sketch by James Holland.

Image credits

The majority of images in this publication are the copyright © of the National Maritime Museum, Greenwich, London, with the following exceptions. For image licensing enquiries for National Maritime Museum images, please contact the Picture Library: pictures@rmg.co.uk.

Pages 48, 71, 76–77, 88, 91, 98, 99, 105, 116, 118, 125, 126–127, 128, 139
© National Maritime Museum, Greenwich, London, Greenwich Hospital Collection

Page 28 redrawn from a manuscript (M.6, f.57v) in the College of Arms

Pages 31, 144–145 © Shutterstock

Page 46 © The Fan Museum, Greenwich

Pages 24–25 © Ashmolean Museum, University of Oxford

Page 109 Royal Collection Trust / © Her Majesty Queen Elizabeth II 2017

Page 122 courtesy of The Metropolitan Museum of Art

Page 161 *Queen Elizabeth II* by Pietro Annigoni. Tempera grassa on paper on panel, 1969.
© National Portrait Gallery, London (NPG 4706)

Page 152 *King George VI* by Dorothy Wilding. Bromide print, May 1946.
© William Hustler and Georgina Hustler / National Portrait Gallery, London (NPG x34050)

Pages 92, 94, 108 © James Brittain / Bridgeman Images

Page 140 © Bridgeman Images

Page 146 © Galerie Bilderwelt / Bridgeman Images

Pages 9, 10, 13, 14 public domain

Front cover:
Greenwich Hospital from the North Bank of the Thames, c.1752, Canaletto
Henry VIII (1491-1547), 16th century, studio of Hans Holbein
The 'Armada Portrait' of Queen Elizabeth I, c.1590, English School
Charles II, c.1660-65, Samuel Cooper

Back cover:
Greenwich from the south-east showing the Park and Tudor palace, about 1620, English School